Commemorating the 150th Anniversary
of the establishment of Canada's first permanent military force.

Farewell To Canada

Now our lot in life is changed
We can no longer stay
We have to speak our sad Farewell
Farewell, Farewell, we say.

"The 60th Farewell to Canada"
Charlie, King's Royal Rifle Corps
Quebec Citadel
10 November 1871

Marc Seguin

FAREWELL TO CANADA

The Last Imperial Garrison
And Canada's First Permanent Force
1867-1871

Featuring artwork by the 19th Century soldier/artist William Ogle Carlile

ONTARIO HISTORY PRESS
2021

ISBN: 978-0-9940106-6-7

ONTARIO HISTORY PRESS
Prince Edward County, Ontario, Canada
2021

Comments and inquiries can be sent by email to the author at
press@ontariohistory.ca

This book is available at local bookstores, from major online book retailers, and at
www.ontariohistory.ca

Other books by Marc Seguin
For Want of a Lighthouse: Guiding Ships Through the Graveyard of Lake Ontario 1827-1914 (2015)
The Cruise of the Breeze: The Journal, Art and Life of a Victorian Soldier in Canada (2018)

COVER ILLUSTRATIONS: William Ogle Carlile, *Canadian Illustrated News*, 2 December 1871.
FRONT COVER – *The 60th Regiment Leaving the Citadel, Quebec* (colourized by Marc Seguin). BACK COVER – *The Royal Artillery Leaving Their Barracks, Quebec.*

Table of Contents

List of Illustrations

Illustrations by William Ogle Carlile

Other Illustrations

Preface

I've always had a keen interest in the documentary art of the soldier/artists who spent time in Canada in the 18th and 19th centuries. One of these military men was Lieutenant William Ogle Carlile. Unlike others who were stationed in Canada, very little of Carlile's original artwork has ever been found. Instead, a number of his paintings and drawings, created in the 1860's and 1870's were published at the time in news magazines and in his own book of recollections.

Many of Carlile's published images graphically document a critical period in Canada's history; a time not long after Confederation in 1867, when the defence of the new country transitioned from the professional troops of the British Army to the citizen-soldiers of the Canadian Militia supported by the first permanent force of regular soldiers that would eventually grow into the modern Canadian Army.

Now, 150 years after the departure of the last British garrison from Quebec City in 1871, a select group of William Ogle Carlile's published illustrations is, for the first time, presented together here to recognize Canada's initial step toward military independence from Great Britain and the British Empire — that moment when the defence of Canada was, for the first time, left solely in the hands of Canadians.

While conducting the research for this book, most archives and libraries had temporarily closed their doors for many months due to the COVID-19 pandemic. Thankfully, many have extensive online resources of which I was able to take full advantage. These include Library and Archives Canada, The Internet Archive, Early Canadiana Online, the U.K. National Archives and many others.

Several individuals also provided me with additional information and research materials. I would like to thank the staff of the Toronto Public Library's Baldwin Collection, Clive Prothero-Brooks of the Royal Canadian Artillery Museum, and Derek Abma in the Public Affairs Office of Canada's Department of National Defence.

I would also like to thank my editor and chief supporter, my wife, Marjorie Cluett Seguin, for her suggestions, encouragement and her sharp eye for detail.

Marc Seguin
October 19, 2021.

Introduction

When the European inhabitants of three British North American colonies celebrated their union and the creation of their new country, the Dominion of Canada, on July 1, 1867, their political independence from Great Britain in all domestic affairs had been achieved. However, thousands of British soldiers then in the country continued to serve as the core of Canada's defence force. The presence of these Imperial troops, supported by the citizen-soldiers of the Canadian Militia, meant that Canada's military independence was yet to come.

One of those British soldiers was Lieutenant William Ogle Carlile, a talented young artist who arrived in Canada with the British Army in 1867. Many of the paintings, drawings and cartoons done by this soldier/artist were published in news magazines of the day, and this artwork forms a unique record of these times of political and military transition.

The British North America Act of 1867 had created Canada as a unique political entity with a constitution devised by Canadians — the "Fathers of Confederation" — but enacted by the Imperial parliament in London. It gave powers to a separate Canadian parliament to make laws and impose taxes, and the authority to bring the neighbouring British colonies and territories into the Canadian Confederation. However, foreign affairs and Imperial defence issues remained in the hands of the British government.

As for local defence, the part-time soldiers of the Canadian Militia were always ready to defend their new country but, even after 1867, they remained in their traditional role as auxiliaries to the regular regiments of the British Army which continued to garrison towns and forts all across the land. For decades, successive British governments had attempted, again and again, to extricate their troops from North America. The colonists, however, were happy to have the regulars stay. The local economic benefits of the presence of large numbers of British troops were certainly appreciated. More importantly, the regular soldiers were seen by most Canadians as a deterrent to

foreign aggression and as their first line of defence against invasion by their powerful neighbour to the south, the United States of America.

It was not until 1871, four years after Confederation, that, amid the strenuous protests of Canadian politicians, the last of the British soldiers defending Canada were withdrawn. Only the Imperial naval base at Halifax retained a small British garrison to guard that strategic station of Britain's Royal Navy. The Canadian government was then left with no choice but to take steps toward their own military independence by establishing the first elements of a permanent Canadian Army consisting of two batteries of artillery to maintain the cannons and fortresses left behind by the British, and to serve as gunnery schools for the Canadian Militia.

Those last years of the British Army defending Canada, from 1867 to 1871, closely coincided with the years during which Lieutenant Carlile served in British North America, giving him the opportunity to document the era through his published paintings, drawings and cartoons.

Many of the details of this transition of the defence of Canada from garrisons of British soldiers to a tiny permanent force supporting Canadian Militia volunteers have been examined by several eminent historians including

C.P. Stacey (*Canada and the British Army*, 1962), J. Mackay Hitsman (*Safeguarding Canada*, 1968) and Richard A. Preston (*The Defence of the Undefended Border*, 1977). However, through his artwork, William Ogle Carlile provides a unique visual perspective as witness to the events of this era during which Canada reluctantly established her own permanent military force, taking the first tentative step toward complete military self-sufficiency on her long path toward greater independence from Great Britain and the British Empire.

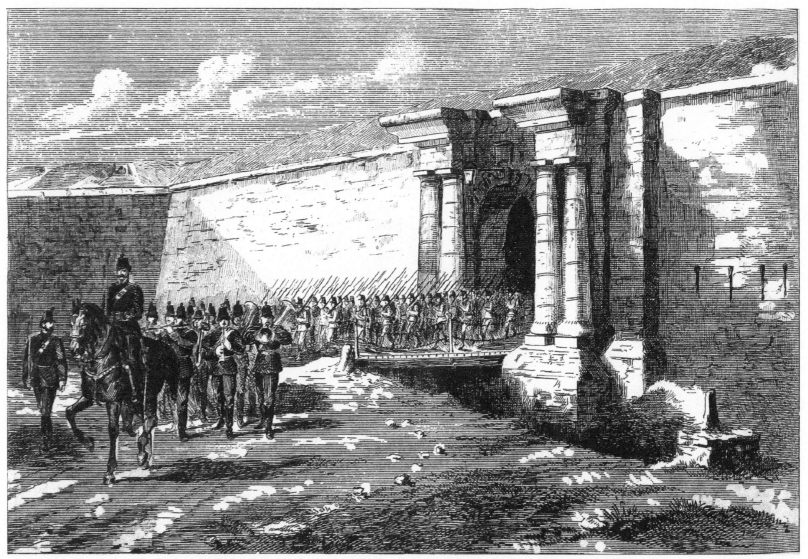

THE 60ᵀᴴ REGIMENT LEAVING THE CITADEL, QUEBEC. FROM A SKETCH BY W.O.C.

Chapter 1

Background –
The Colonial Garrisons

On the bright, crisp afternoon of November 11, 1871, the band of the 60th Regiment, the King's Royal Rifle Corps, struck up the regimental march, "The Huntsman's Chorus", as the entire battalion, almost one thousand strong, resplendent in their "rifle green" uniforms, marched out of the Quebec Citadel, their commanding officer leading on horseback. As they made their way through the narrow, winding streets of Quebec City, they joined a column of soldiers of the Royal Regiment of

Artillery and the Corps of Royal Engineers, and together the procession marched down to the St. Andrew's wharf, the band playing "Goodbye Sweetheart Goodbye" as they boarded the troopship, *HMS Orontes*, which was waiting to transport them down the St. Lawrence River, never to return.

Beginning in the 17th Century and continuously for more than two hundred years, the armies of France and, later, Great Britain, maintained garrisons of regular troops in towns, forts and outposts scattered across what is now eastern Canada. These colonial garrisons protected the overseas territories of the European imperial powers, acting as the first line of defence against invaders and providing rallying points for the local militia in times of war. The often poorly armed and untrained militiamen — usually all able-bodied males between the ages of eighteen and sixty — were, from time to time, called up for extended active service to aid the European troops in defence of the colonies, and various volunteer companies

OPPOSITE — William Ogle Carlile, 1871.
The 60th Regiment Leaving the Citadel, Quebec.
[*Canadian Illustrated News*, 2 December 1871.]

Major R.J.E. Robertson, on horseback, leading the 1st Battalion of the 60th Regiment (King's Royal Rifle Corps), out of the main gate of the Quebec Citadel, on November 11, 1871. This regiment, along with the Royal Artillery and Royal Engineers, were the last British military units to garrison Quebec City.

and local battalions were occasionally raised from the colonial population to augment the regular regiments for short periods of time. However, most of the burden of defending the colonies fell to the professional soldiers manning the North American garrisons, and the cost of building forts and barracks and paying, feeding and clothing these troops and transporting them to and from North America was largely the responsibility of the Imperial powers.

At the end of the Seven Years' War in 1763, all of the French garrisons were withdrawn from North America when most of New France was ceded to Great Britain by the King of France in exchange for the French West Indian sugar islands which the British had captured during the war.[1] By 1783, however, Great Britain had lost her thirteen American colonies to the south as a result of the American War of Independence. The British Army then concentrated its troops in a number of small garrisons in what are now the Canadian provinces of Newfoundland, Nova Scotia, Prince Edward Island, New Brunswick, Quebec and Ontario. Three decades later, after the War of 1812 was fought to a stalemate between Britain and the young United States of America, fear of future invasions by the Americans compelled the British to strengthen their garrisons of regular troops in North America.

In 1815, the British North America consisted of seven colonies: Newfoundland, Cape Breton Island, Nova Scotia, New Brunswick, Prince Edward Island, Lower Canada and Upper Canada. In 1820, Cape Breton Island was incorporated into the Province of Nova Scotia. In 1841, Upper Canada and Lower Canada were combined into a single colony, The United Province of Canada — Upper Canada was officially known as Canada West (changed to the Province of Ontario after Confederation in 1867), and Lower Canada became Canada East (changed to the Province of Quebec in 1867). In 1849, the Pacific coast colony of Vancouver Island was formed, followed by the colony of British Columbia in 1858. These two colonies united in 1866 under the name British Columbia.

By the middle of the 19th Century, changing Imperial priorities resulted in the British government questioning the enormous cost of maintaining garrisons in these colonies as well as in other colonies, protectorates, occupied territories and naval bases of the British Empire scattered all around the globe. There was a special focus on the British North American colonies as they were all largely self-sufficient economically and, by the 1850's, all had been granted responsible self-government.[2] Each of these colonies had their own elected legislatures with the power to raise their own taxes and make their own laws governing internal affairs; the Imperial parliament in London retaining responsibility for foreign relations and defence.

In 1851, a new colonial policy reflecting the "Little England" view of Britain's Whig party (later, the Liberal party) — a view opposing the Conservative party's general

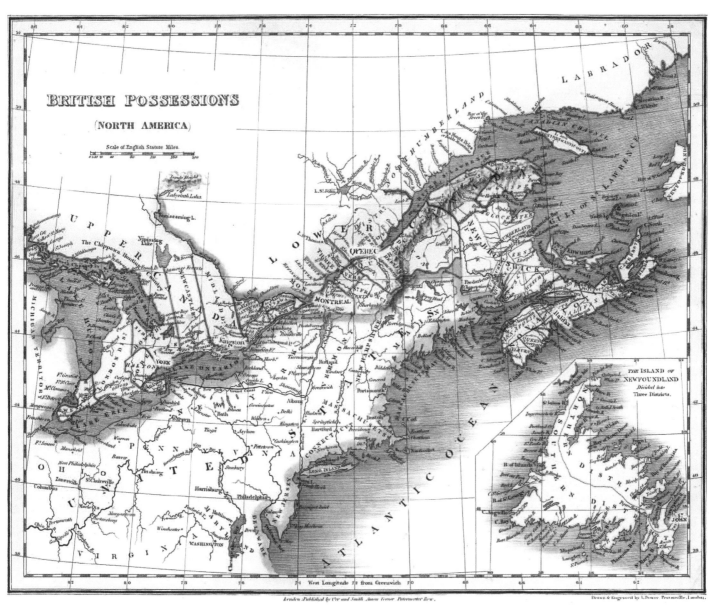

J. Dower, 1832.
British Possessions (North America).
[From *A General Descriptive Atlas of the Earth*, London, 1832. p. 38. Courtesy of The David Rumsey Map Collection, Cartography Associates.]

The colonies of Upper Canada (later Ontario) and Lower Canada (later Quebec) were united in 1841 to form the Province of Canada. Nova Scotia, New Brunswick and the Province of Canada united in 1867 to form the Dominion of Canada.
The colony of Newfoundland is shown inset at lower right.
The Pacific coast colonies of British Columbia and Vancouver Island are not shown on this map.

9

policy of expansion of the British Empire — was articulated by Britain's colonial secretary, the Earl de Grey:

> [The Province of] Canada (in common with the other British Provinces in North America) now possesses in the most ample and complete manner in which it is possible that she should enjoy it, the advantage of self-government in all that relates to her internal affairs.
>
> It appears to Her Majesty's Government that this advantage ought to carry with it corresponding responsibilities, and that the time is now come when the people of [the Province of] Canada must be called upon to take upon themselves a larger share than they have hitherto done of expenses which are incurred on this account, and for their advantage.
>
> Of these expenses, by far the heaviest charge which falls upon this country [Great Britain], is that incurred for the military protection of the Province.
>
> Regarding [the Province of] Canada as a most important and valuable part of the Empire, and believing the maintenance of the connection between the mother country and the Colony to be of the highest advantage to both, it is far from being the view of Her Majesty's Government that the general military power of the Empire is not to be used in the protection of this part of Her Majesty's Dominions.
>
> But looking to the rapid progress which [the Province of] Canada is now making in wealth and population, and to the prosperity which she at this moment enjoys, it is the conviction of Her Majesty's Government that it is only due to the people of this country [Great Britain] that they should now be relieved from a large proportion of the charge which has hitherto been imposed upon them for the protection of a Colony now well able to do much towards protecting itself.[3]

In spite of the colonial secretary's pledge of continued military protection of the colony, there was an immediate reduction in the number of regulars in British North America from 8,800 soldiers to 6,900, and the sought-after reduction in the cost of the garrisons followed.[4]

Two years later, Britain's desperate need for troops to fight the Russians during the Crimean War (1853-1856) resulted in the withdrawal of more soldiers from the colonies. By 1855, there were only 3,200 regulars remaining in North America,[5] concentrated largely in garrisons at Kingston, Quebec City, and Halifax. At the same time, North American military expenditures had been cut in half, from £460,000 to £230,000.[6]

British parliamentarians were undoubtedly pleased when they saw that the new colonial policy seemed to be encouraging some of the colonial governments to take a greater interest in self-defence. Both Nova Scotia and the Province of Canada passed new militia bills during the Crimean War authorizing the formation and training of part-time volunteer corps. These volunteers, in very practical terms, gave real substance to the old Sedentary Militia which had devolved into an untrained paper force —

simply a list of names on a muster roll. While some units of the modern Canadian Army trace their roots back to these part-time volunteer corps, it would still be several years before the first permanent elements of a professional, regular army were established.

The patriotic zeal of a group of colonials took this a step further when, by 1858, they would raise a new, all-Canadian infantry battalion, the 100th Regiment (Royal Canadians), recruited exclusively in the Province of Canada as a regular regiment of the British Army for service anywhere in the Empire.[7] The British government hoped that the colonies' increased interest in Imperial military matters, along with these initial steps toward shouldering a greater share of their own defence in light of the new colonial policy, would ultimately lead to even more financial relief for Britain. However, as Britain's secretary of war, Edward Cardwell, would later note, "Very exceptional circumstances... prevented the application of these principles to the British North American Provinces".[8]

The first of these "exceptional circumstances" had already been thrust upon the colonies in 1856. A minor diplomatic spat over the British Army's overt recruiting of American citizens to fight in the Crimea, exacerbated by a disagreement between the United States and Great Britain over Central American affairs, resulted in the precautionary reinforcement of the North American garrisons with five British infantry battalions together with artillery;

doubling the total number of regulars to more than 7,000.[9] While this number was reduced to 4,500 soldiers by 1858, Britain was still shouldering more than eighty percent of the financial burden of the defence of British North America.[10]

By 1860, tensions between the United States and Great Britain had eased and relations between the two countries were so cordial that Queen Victoria's eldest son and heir to the throne, Edward, Prince of Wales, extended his royal tour of British North America to include several unofficial stops in the United States where he was received with great enthusiasm wherever he went. However, the next "exceptional circumstance" was just around the corner: the outbreak of the American Civil War in April, 1861.

At that time, there were as few as 4,200 British regulars scattered across the North American colonies,[11] but that number was quickly increased. Soon after the outbreak of war between the Union forces of the North and the Confederate forces of the South, ill-will between the United States and Great Britain began to build over several issues. The Americans were offended at Britain's declaration of neutrality which was perceived in the U.S. as *de facto* recognition of the legitimacy of the Confederate States of America. The British resented President Abraham Lincoln's declaration of a naval blockade of Confederate ports which cut off exports of raw cotton to British textile manufacturers and quickly led to many British vessels running the Union blockade.[12]

In the summer of 1861, Britain's War Office ordered a precautionary reinforcement of the garrisons in the Province of Canada. Three thousand troops, including a battery of field artillery armed with the latest Armstrong breech-loading cannons, augmented the North American garrisons.[13] In response, the U.S. government began planning for additional fortifications along the border with the British provinces as well as along the Atlantic seaboard to guard against the possibility of bombardment from ships of the Royal Navy.[14]

Feelings of ill-will between the two countries turned to threats of all-out war when, on November 8, 1861, the United States warship, USS *San Jacinto*, commanded by the impetuous Captain Charles Wilkes, fired on the unarmed British mail steamer, *Trent*, in international waters off the coast of Cuba, forcing the British ship to halt on the high seas. A boarding party of U.S. Marines forcibly removed from the *Trent* four Confederate envoys — James Mason, John Slidell, William McFarland and George Eustis — who were on the British steamer making their way to Europe on a diplomatic mission for the Confederate States of America.

When news of the "*Trent* Affair" reached Britain three weeks later, Prime Minister Lord Palmerston called an emergency meeting of his cabinet to determine a course of action to address, "the outrage on the British flag perpetrated by a United States ship of war."[15] Within days, there was public outcry against the Americans all across Britain fuelled by countless fiery newspaper editorials of "Yankee treachery" on the high seas.[16] The actions of Captain Wilkes were seen by British officials as a serious breach of international law, and the diplomatic incident that it sparked escalated with great rapidity toward full-scale war.

Lord Palmerston's cabinet drafted a terse ultimatum to the United States demanding the immediate release of the four diplomats along with an apology for the incident. In the absence of an unequivocal response to the British ultimatum, the Royal Navy was under orders to send a squadron of some thirty iron-clad warships to blockade all of the major Northern ports from Maine to Maryland. One of the British war plans went so far as having the British fleet bombard New York City and capture Portland, Maine, the strategic ice-free Atlantic port that could then be used by the Royal Navy as a coaling and supply station to refuel and refit its steamships.[17] Portland was also important because of its direct rail links to Montreal and Quebec City which would allow the British Army's commanders to send troops and supplies quickly to and from the Province of Canada so that they would not have to rely on sailing up the ice-choked St. Lawrence River.

Without waiting for a reply from the Americans, Palmerston ordered some 12,000 troops to North America. Over the course of the following five weeks, Britain's War Office pressed into service seventeen British

ships, all packed with soldiers, artillery, ammunition and other war materiel. Dispatched from ports all around Britain, the ships sailed to Halifax, Nova Scotia, one of the only ice-free ports in British territory. From Halifax, the troops were ferried to Saint John, New Brunswick and then onward to the Province of Canada by way of an incredible relay of horse-drawn sleighs which crossed three hundred miles of wintery wilderness to the railhead of the Grand Trunk Railway at Riviere du Loup on the St. Lawrence River. From there, the troops travelled by train to their new posts at Quebec City, Montreal, Kingston and Toronto.

By the time the first regiments arrived at their new quarters, President Lincoln had already ordered the release of the Confederate diplomats, so war between the United States and Great Britain was averted. Had war come, though, Canada would have been the battleground. This was a crucial point which was reiterated by Canadian politicians whenever the subject of British troop withdrawals was suggested by the Imperial government. Canadians argued that Imperial troops had to remain in Canada in the event of a war that might be brought on as a result of Imperial policies.

By the spring of 1862, the British North American garrisons contained some 17,500 soldiers — more British regulars in North America than at any time since the end of the War of 1812 — and the "*Trent* Affair" troop deployment had more than tripled the cost of defending the

Artist unknown, 1862.
The Reinforcements for Canada Passing Through New Brunswick.
[*Illustrated London News*, 29 March 1862.]

As a result of the "*Trent* Affair", by early 1862, more than 12,000 troops had been sent from Britain to reinforce the garrisons in North America.

colonies — an additional £640,000 over and above the budgeted funds for that fiscal year had to be allocated by Britain's War Office to pay for troop transport, extra barracks, rations, winter clothing, fortifications, and other military necessities.[18]

As the reinforcements settled into garrison life in North America early in 1862, British parliamentarians quickly reaffirmed the Liberal party's colonial policy of a decade earlier:

> Resolved — This House, while fully recognising the claims of all portions of the British Empire to Imperial aid in the protection arising from the consequences of Imperial policy, is of opinion that Colonies exercising the right of self-government ought to undertake the main responsibility for providing for their own order and security, and ought to assist in their own external defence.[19]

The War Office was successful at quickly applying this policy to British garrisons in other parts of the Empire. Troops were immediately withdrawn from the Australian colonies and most of the army's soldiers in New Zealand would be returned to Britain within a few years.[20]

In North America, however, the colonial governments expressed considerable resistance to the policy of troop withdrawal, and they had little interest in paying for their own defence. When the governor-general of British North America, Viscount Monck, remarked how little

money the legislature of the Province of Canada had voted toward its own militia and defence for 1862, the newly appointed Liberal premier of the province, J.S. Macdonald, elaborately stated the province's view on the issue:

> That the right of self-government has for a corelative duty the maintenance of provision for defence, is a proposition which in the abstract, is indisputable; but it is only indisputable in the case of Governments of States which are Sovereign in themselves — as between a Colony and the parent State, it cannot be said to exist in the same sense.
>
> A British Colony must submit to all the consequences of conflict produced by the policy which Her Majesty's Government may carry out in the interest of the Empire at large.... A Colony so situated must endure all the consequences of a line of action which its own Legislators have no voice in originating and towards the termination of which they can do nothing.
>
> In the case of [the Province of] Canada, the strongest advocates of the new theory of the Colonial relation are compelled to admit that an exception to the general rule must be made. Even they who demand the withdrawal of all Troops from self-governing Colonies are obliged to concede that some special allowance must be made in favour of [the Province of] Canada. Their reasons for an exceptional policy towards this Province are apparent; situated on the border of a vast and powerful Republic, with a frontier extending upwards of a thousand miles, with no deep back country to sustain it,

and accessible in case of war at numerous points, it is admitted that [the Province of] Canada should be assisted to the full extent of the Imperial resources....

Your Excellency's Advisers would not be faithful to their own convictions or to the trust reposed in them if they withheld an expression of their belief, that without very large assistance any efforts or sacrifices of which the people of the Province are capable would not enable them successfully and for any lengthened period to repel invasion from the neighbouring Republic. They have relied for protection in some degree upon the fact that under no conceivable circumstances will they provoke war with the United States, and if therefore [the Province of] Canada should become the theatre of war resulting from Imperial Policy, while it would cheerfully put forth its strength in the defence of its soil, it would nevertheless be obliged to rely for its protection mainly upon Imperial resources. And in such an event it is their opinion that they would be justified in expecting to be assisted in the work of defence with the whole strength of the Empire....

No portion of the Empire is exposed to suffering and sacrifices equal to those which would inevitably fall upon this Province in the event of war with the United States....

Your Excellency's Advisers advert to these contingencies of our position, not to justify inaction but to shew the unfairness of demands predicated upon alleged selfishness and sloth on the part of Canada. They simply point to consequences which it is criminal to conceal and to dangers which it is

folly to deny....They have reminded Your Excellency that the appropriation obtained from [the Province of Canada's] Parliament is as large as the state of the finances will allow it to be, and they have glanced at their plans for the purpose of proving the wisdom and justice of their courage. Their anxiety is to do all that ought to be done, and to do this in a manner acceptable to the Province.[21]

A new Militia Bill which had earlier been introduced by the province's previous Conservative government had suggested that more than $1 million would be allocated for local defence. This would have addressed many of the governor-general's concerns, but the bill had been defeated in the legislature and the minority government had fallen over the issue. Later that year, limited numbers of British troops were withdrawn from North America, but as further tensions arose with the United States, troop reductions were halted once again.

In 1865, the American Civil War came to an end. Some observers in British North America had already cautioned that, with more than one million men under arms, the United States Army might simply turn its sights from the rebels in the south to the British in the north:

The United States of America are now a military power, and have demonstrated their capability of raising and equipping in a short space of time an

enormous mass of troops, and of bringing them to bear on any part of their enemy's frontier that may be necessary.[22]

In all of British North America, there were only 12,000 regulars thinly spread along a frontier of more than 1,500 miles from New Brunswick's Bay of Fundy to the eastern edge of Lake Superior.[23] Fortunately, most Union Army regiments were quickly disbanded and war-weary Americans were happy to return to civilian pursuits. Although several American politicians began advocating for the annexation of their northern neighbours to the United States, few Americans wanted little to do with another war. Nevertheless, the ill-will that had arisen between the United States and Great Britain during the Civil War lingered for many years. Cross-border raids towards the end of the war against Sandusky, Ohio and St. Albans, Vermont by Confederates based on neutral Canadian territory had served to heighten tensions, but much of the continued resentment on the part of the Americans centered around the privateering activities of the ship, the *CSS Alabama,* and other Confederate commerce raiders that had been built in supposedly-neutral British shipyards for use by the rebel navy against U.S. shipping. The U.S. government terminated the 1856 Reciprocity Treaty with the Province of Canada over this issue and the

Americans further threatened to abrogate the 1817 Rush-Bagot Agreement that limited the number of armed vessels on the Great Lakes. As compensation for the *Alabama* Claims, some American politicians went so far as to demand that Britain pay for half the cost of the war — an amount arbitrarily suggested to be $125 million dollars in reparations — or immediately cede the Province of Canada to the United States.[24]

To exacerbate this state of affairs even further, rumours of pending attacks against British targets in North America by the U.S.-based Fenian Brotherhood were rampant. The Fenian Brotherhood, dedicated to "physical-force nationalism", was a secret para-military society acting as the American branch of the Dublin-based "nationalist revolutionary organization" known as the Irish Republican Brotherhood whose objective was to free Ireland from British rule.[25] Many Fenians were battle-hardened Union Army veterans who carried with them a deep resentment of the British due to oppressive British land laws in Ireland that had forced many of them to leave their homes during and after the Irish Potato Famine of the 1840's.

As a precaution, in March 1866, the Province of Canada called out 10,000 militia volunteers for active service, and troops in Nova Scotia and New Brunswick were placed on alert. The following month, an attempted

raid by a band of 700 Fenians against Campobello Island, New Brunswick, was thwarted by British forces. Then in June, some 1,200 armed Fenians crossed the Niagara River and engaged with companies of Canadian volunteers at Ridgeway, with casualties on both sides. On the approach of British regulars two days later, the Fenians withdrew back to Buffalo, New York, where many were arrested by U.S. authorities. That same week, a planned attack on the town of Cornwall in Canada West, from a Fenian base at Malone, New York, was thwarted by the U.S. Army. In Canada East, 1,000 Fenians occupied the area around Pigeon Hill, forty-five miles south-east of Montreal, but most retreated back to American territory after the U.S. Army stopped their reinforcements from crossing the border.[26]

These cross-border incursions were yet another "unexpected circumstance" that not only delayed further withdrawal of British troops from the North American garrisons, but resulted in their numbers increasing. Reinforcements in 1866 brought the total number of regulars in British North America back up to 15,000, most of them stationed in the Province of Canada.[27] Even though the province had to pay the expenses of extra barrack accommodations for the British regulars in a number of towns and cities including Hamilton, Brantford, London, Toronto and Ottawa, as well as spending more

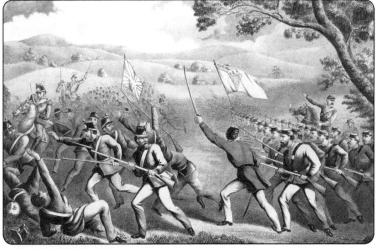

Chas. Hart (lith.), 1870.
The Battle of Ridgeway C.W. [Canada West] **June 2nd 1866**.

This fanciful image shows the Fenians (right) advancing against the Canadian volunteers.
The original lithograph was incorrectly printed in reverse. The image has been printed correctly here.
[Thos. Kelly (publ.), New York, 1870. Courtesy of U.S. Library of Congress, LC-DIG-pga-01485.]

than $1,000,000 on the volunteer militia called up for "frontier service",[28] Britain's War Office still had to shoulder the greater expense of transporting, feeding and paying their own troops, which amounted to almost $3,000,000.[29]

The defence concerns highlighted by the American Civil War and the Fenian raids were significant contributing factors to the British North American colonies' move toward Confederation. Such a union had been proposed by Lord Durham decades earlier, and the government of the Province of Canada had commented on, and rejected, such a proposition as late as 1862:

> A union for defence is proposed by His Grace the Secretary of State for the Colonies [the Duke of Newcastle]; a union of the British North American Provinces for the formation and maintenance of one uniform system of Military organization and training, having a common defensive fund and approved by Her Majesty's Government....
>
> Although this Government [of the Province of Canada], looking at it mainly as a means of defence, has entertained the preliminaries in common with Delegates from the Provinces of Nova Scotia and New Brunswick, it is premature just now to speculate upon the possible political consequences of an undertaking which may never be consummated....[30]

However, only two years later, the course of the American Civil War had turned decidedly in favour of the Union whose massive army might be used to invade Canada after the southern rebels had been subdued. Formal talks about a political, economic and military union among five of the British North American provinces were then begun in earnest. Representatives from Newfoundland, Nova Scotia, Prince Edward Island, New Brunswick and the Province of Canada met at Charlottetown in September, 1864, and then again at Quebec City the following month.[31] While Prince Edward Island and Newfoundland had reservations about the Confederation scheme at that time, the other three colonies agreed on seventy-two resolutions that would form the basis of a new constitution to be proposed to the Imperial authorities when colonial delegates met to discuss Confederation in London in 1866.

Prior to that, in March 1865, the legislature of the Province of Canada voted overwhelmingly to adopt the seventy-two resolutions that came out of the Quebec Conference,[32] and the following month, just as the main Confederate Army was surrendering to the Union Army to end the American Civil War, a delegation of the province's leaders was sent to Britain to discuss a number of critical matters that would help pave the way for union of the North American colonies.

On their return home in July, 1865, the delegation, which included John A. Macdonald, George-Etienne Cartier, George Brown and Alexander Galt, reported to the governor-general on their talks with British

Colonial Secretary Edward Cardwell and a number of his cabinet colleagues:

The circumstances under which this mission became necessary are doubtless fresh in Your Excellency's recollection. For a considerable time past, in view of the Civil War going on in the United States, and the impossibility of anticipating what international questions might at any moment arise, Her Majesty's Government felt it their duty from time to time to direct the attention of the Government of [the Province of] Canada to the insecure position of the Province in the event of disturbed relations unhappily resulting, and to urge the adoption of protective measures....

The subject to which we first invited the attention of the Conference was the proposed Confederation of the British North American Colonies. We reminded the Imperial Ministers how largely all the questions, with the discussion of which we were charged — and especially those of defence, Foreign Commercial relations, and internal communication — would be affected by the Union, and how greatly their satisfactory settlement would be facilitated by it.... We received at once from the Members of the Imperial Cabinet assurances of their hearty approval of the Confederation scheme, and of their anxious desire to promote its early accomplishment, by all the legitimate influence of the Imperial Government.... In the course of these discussions, the question of the Intercolonial Railway came up as a necessary accompaniment of Confederation, when we sought and obtained a renewal of the promised Imperial guarantee of a loan for the construction of that work.

The important question of the future military relations between the Mother Country and [the Province of] Canada received earnest and grave consideration....

We expressed the earnest wish of the people of [the Province of] Canada to perpetuate the happy existing connection with Great Britain, and their entire willingness to contribute to the defence of the Empire their full quota, according to their ability, of men and money. But we pointed out that if war should ever unhappily arise between England and the United States, it could only be an Imperial war, on Imperial grounds — that our country alone would be exposed to the horrors of invasion — and that our exposed position, far from entailing on us unusual burdens, should on the contrary secure for us the special and generous consideration of the Imperial Government....

Much discussion ensued on all those points, and the result arrived at was, that if the people of [the Province of] Canada undertook the works of defence at and west of Montreal, and agreed to expend in training their militia, until the union of all the Provinces was determined, a sum not less than is now expended annually for that service [$1,000,000], Her Majesty's Government would complete the fortifications at Quebec, provide the whole armament for all the works, guarantee a loan for the sum necessary to construct the works undertaken by [the Province of] Canada, and in the

event of war undertake the defence of every portion of [the Province of] Canada, with all the resources of the Empire.

... It was therefore deemed inexpedient to complicate the Confederation question by changing the basis of the Quebec Conference Resolutions.... The further consideration of the defensive works was accordingly deferred for the action of the Government and Legislature of the proposed British North American Confederation....

It will be gratifying to many devoted subjects of Her Majesty throughout British America, whose fears have been excited by the language too often heard of late years, on the subject of Colonial Connection, that we received from Her Majesty' Ministers the assurance that the British Government acknowledge the obligation of defending every portion of Canada with all the resources at its command....[33]

After the Imperial government exerted its "legitimate influence" on the hesitant maritime provinces to join the Confederation of the British North American colonies, the London Conference was convened in December 1866, attended by delegates from Nova Scotia, New Brunswick and the Province of Canada (which would be divided into the new provinces of Quebec and Ontario). The Imperial parliament, now controlled by a Consevative majority, expressed their full support of the Confederation plan which included a new constitution incorporating the seventy-two

resolutions. In addition, the British government confirmed a loan for £3 million to allow Canada to finance the construction of the long-planned Intercolonial Railway which would physically connect all of the provinces together. The Confederation of the North American colonies would relieve the British taxpayer of the financial burden of maintaining garrisons in those colonies. The Intercolonial Railway would provide a viable supply route for British troops in the event that an armed conflict with the United States during the winter forced the British government to make good on its promise to come to Canada's aid.

In March 1867, the Imperial parliament passed the British North America Act (later renamed the Constitution Act) to unite the colonies. They also approved the Intercolonial Railway loan guarantee. Upon the passage of the legislation, the London *Times* printed an editorial reflecting the views of the government and of many Britons:

The [Intercolonial Railway loan] scheme has been incorporated in the Confederation Bill, which gives it the appearance of a bargain made by the Colonies, or some active Colonial politicians, as the condition of their effecting the Provincial Union [Confederation]....

If by enabling Canada to make this railway the Mother Country is to be held to have now fulfilled all its duties, and to be henceforth entirely at liberty

to consult its own interests, we cordially approve its decision. The first and most important of our duties will then be the speedy withdrawal of all British troops from the North American Continent. To keep a force of 12,000 or 14,000 men scattered along such a line of frontier... and to defend it against a people of thirty-five millions [the United States of America], is an absurdity which must be obvious to every one, whether soldier or civilian....

Let it be clearly understood that the guarantee of the Canada Railway Loan carries with it the responsibility of self-defence to be undertaken by the Confederation, and that it is the intention of the Queen's Government to withdraw at no distant time all British troops from the American Continent.[34]

On July 1, 1867, the British North America Act came into effect, creating a new country, the Dominion of Canada; a country formed, not out of violence or rebellion, but a self-governing state born of amalgamation and negotiation; autonomous, yet still part of a greater entity, the British Empire.

The British Army continued to have a strong presence in the new country. In spite of the decades-old Imperial policy to the contrary, more than 15,000 troops still garrisoned Canada's three major fortresses — Halifax, Quebec and Kingston — with many also stationed in numerous other forts, barracks and detached outposts scattered along the frontier. With a powerful, disgruntled neighbour on her borders still demanding restitution over

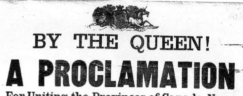

[From Adam Short and Arthur G. Doughty, *Canada and Its Provinces,* vol. 6, Toronto, 1914. p. 20.]

The Imperial parliament passed the British North America Act on March 29, 1867. Queen Victoria proclaimed the creation of the Dominion of Canada on May 22, to take effect on July 1, 1867.

the *Alabama* Claims, and Fenian raiders threatening more armed incursions into Canada, the policy of Imperial troop withdrawal from North America stalled yet again.

Within three months of Canadians celebrating the birth of their new country, a cohort of Imperial soldiers — what would ultimately be the last of their kind sent to defend Canada — arrived at Quebec City.[35] These included an infantry regiment, the 1st Battalion of the 60th Rifles (King's Royal Rifle Corps), and an artillery brigade, the 3rd Garrison Brigade of the Royal Regiment of Artillery.

Among this group of British soldiers was Lieutenant William Ogle Carlile.

Over the next several years, in addition to performing his military duties, the soldier/artist, W.O. Carlile, would document many aspects of life in Canada by producing a substantial body of artwork. Many of the paintings, drawings and cartoon sketches that he created during this period were published in books and magazines of the day. These images included numerous scenes illustrating many aspects of the last years of the British Army's presence in Canada and the preparations being made for reducing and eventually withdrawing the Imperial troops from the new country in 1871, which would then leave the defence of Canada solely in the hands of Canadians.

OPPOSITE — William Ogle Carlile, c.1870.
Quebec.
[From *Recollections of Canada*, London, 1873.]

This view from Pointe Lévis shows Quebec City as it would have looked when Lieutenant Carlile saw it on his arrival in 1867. Across the St. Lawrence River, the Lower Town with the city's wharfs can be seen at the water's edge, with the Upper Town rising up behind it and the Quebec Citadel, the fortress on Cape Diamond, to the left.

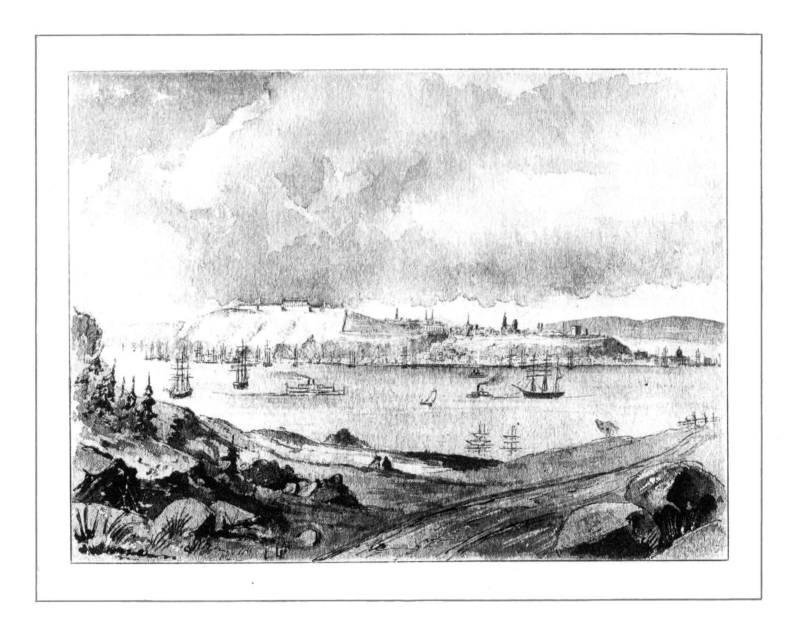

QUEBEC.

Chapter 2

William Ogle Carlile

William Ogle Carlile was born into an affluent Anglo-Irish family at Blackrock, in Dublin County, Ireland, on August 26, 1839. At a young age, William was inspired to pursue a military career, likely influenced by stories of the national hero of the era, Dublin-born Arthur Wellesley, the Duke of Wellington, victor over Napoleon at the battle of Waterloo a quarter-century earlier.

A position as an officer in the British Army would be a respectable career for any Victorian gentleman, but it could also be an expensive undertaking. Until 1871, most young men desiring an officer's commission in the army would require two things: impeccable references from prominent friends or distinguished army officers, and a minimum of £450 (roughly equivalent to CDN$83,000 in 2021 dollars) to purchase an entry-level position as an ensign in an ordinary infantry regiment.[1] Commissions in the Brigade of Guards or in cavalry regiments were priced even higher.

Whether because his family was concerned about the price of a commission, or perhaps because William was more interested in the "scientific" branches of the British Army, he decided to seek a commission in the Royal Engineers or Royal Artillery where the principal qualifications were to gain admission to the Royal Military Academy (RMA) at Woolwich, near London, and then to graduate after two years of study. In this way, young William's army commission would not have to be purchased. However, being an officer in any branch of the British Army was an expensive proposition. All officers were considered to be gentlemen and, as such, a certain standard of behaviour was expected of them including an expectation that they could afford a very high standard of living. That standard included lavish dining with copious amounts of food and expensive wines, as well as certain gentlemanly pastimes including fox hunting, shooting and theatre subscriptions, all of which cost much more

than the inadequate pay that officers received from the government. In addition, officers were required to purchase their own uniforms as well as their own swords, pistols and other accoutrements. This could amount to well over £100 (CDN$18,500 in 2021 dollars).[2] There were also various regimental fees to be paid including mandatory mess dues and regimental band subscriptions.

A junior artillery lieutenant was paid only £125 per year[3] from which he would have to pay for his own accommodations when not in barracks, as well as for his own food and clothing. However, it was estimated that young subalterns (the term used for all army officers under the rank of captain; i.e., ensigns, cornets and lieutenants) required an additional £60 to £100 per year over and above their wages just to cover their extra messing and other regimental expenses.[4]

Even before sitting the RMA entrance exams, most candidates would have to incur the added expense of a course of study at a preparatory school in order to have any hope of making the grade. A good grounding in Classics and Drawing was useful, and an excellent knowledge of Mathematics was essential. Under the merit system of entry to "The Shop", as the Royal Military Academy was called, there was considerable competition for the few seats available every year. Universities, including the University of Dublin where William Carlile studied, as well as Oxford and Cambridge, had special academic programs just to prepare their students for entrance to the Academy. Numerous private schools had also sprung up across Britain with curricula designed specifically for those students who desired to sit the RMA entrance exams. Tuition fees at any of these institutions could cost several hundred pounds sterling. If a candidate were successful gaining admission to The Shop, there were still fees to pay: £22 10s. to cover the cost of uniforms and books, plus £62 10s. per term in academic fees. With two terms per year, the total fees were not inconsiderable and would easily exceed £250 for two years of schooling (more than CDN$46,000 in 2021 dollars).[5]

In the summer of 1859, just shy of his twentieth birthday, William Carlile boarded the ferry at Dublin, crossed the Irish Sea, travelled by train for one whole day and night through Wales and England to London's Euston station, then by coach to the Chelsea Hospital where, over a period of nine days, he sat the entrance exams for admission to the Royal Military Academy. Shortly after returning home to Ireland, William was informed that he had ranked seventeenth in a cohort of forty examinees,[6] sufficiently high that, in March, 1860, he was appointed to the Company of Gentleman-Cadets at the Royal Military Academy, Woolwich.

Located on the banks of the Thames River, one 19th Century chronicler described the town of Woolwich and the Academy as they appeared in 1860:

> Barracks, military hospitals, stores of ammunition and of arms — all of these give it a warlike stamp, which contrasts with the peaceful appearance of the majority of English towns. The town itself... has nothing gay nor attractive, but in front of the barracks there is an immense open plain. To the right of this plain (Woolwich Common) a tent-shaped edifice is erected, the Rotunda. To the left, at the extremity of the plain, stands the Royal Military Academy. The centre consists of a solid square building with four turrets, crowned with octagon domes, and two wings, which extend on each side in a straight line. Before the front extends Woolwich Common, behind the rises of Shooter's Hill.[7]

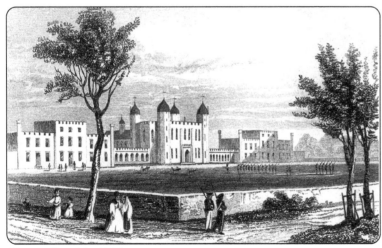

Thomas Dugdale, 1845.
Royal Military Academy, Woolwich.
[Author's collection]

Like all "neux" or "snooks" (rhymes with "dukes") or "snookers", as new cadets were called, Gentleman-Cadet Carlile started in the Theoretical Class where he was instructed in academic subjects such as Mathematics, French, German, Chemistry, Geology and Astronomy, in addition to learning the standard foot drills and small-arms drills of the 19th Century British soldier. Although the gentlemanly arts of fencing and dancing had been dropped from The Shop's curriculum some years earlier, as gentlemen, all British Army officers were required to

ride, so equestrian instruction at the Royal Artillery Riding Establishment was also part of the course of study. In addition, there were several courses in drawing: geometrical drawing, military plan drawing, surveying and sketching, and landscape drawing. These art subjects were more than just an attempt at imparting gentlemanly refinement to the cadets. In an age before portable cameras were readily available and aerial reconnaissance was largely unknown, painting and drawing were often the best ways for military observers to produce an accurate representation of the ground to illustrate a potential defensive position or a possible battlefield location.[8] Such graphical information might then be used by military commanders to deploy their troops with greater effect. Noted landscape painters of the day including James Bridges, George Campion, Aaron Penley and John Callow were all on staff at various times at RMA Woolwich as Masters for Landscape Drawing,[9] and these instructors likely had a significant influence on Carlile's later artwork.

Some aspects of life as a new cadet at the Royal Military Academy at the time that William was a student at The Shop were described by another graduate of RMA Woolwich:

> Those were the days of bullying, and the 'snookers' — as the two junior batches were termed — had a very hard time of it. There were four cadets in each room, the corporal, or 'head of the room', being in charge; the poor snookers had often a terrible time of it, and were fagged and unmercifully thrashed with belts and tennis-bats.
>
> The baths were in the yards, supplied with cold-water taps only; in the winter these froze, and we 'snookers' had to fill the baths in the mornings with 'tosh-cans' from the pumps — a dreadfully cold business when it was freezing or snowing, and one had only a pair of trousers and dressing-gown and slippers on! In summer, we also bathed at the cadets' pond near the Repository, and were taught to swim more or less by repeated duckings. We also went to the Repository for heavy gun drill and mortar practice; and used actually to fire at a mark placed on the upper part of the Common, notwithstanding that a cadet had some years before been killed by one of the bursting shells.
>
> We were very hard-worked, the régime being about as follows: Study 8 to 11; drill 11:15 to 1; study 2 to 4:30; drill for an hour, and study 6 to 8.[10]

Lifelong friends were made at the Academy. Two of William's classmates, De La Cherois (Delroy) Thomas Irwin and upper-classman George Arthur French — who, like William, were both from Anglo-Irish families[11] — would serve with him in Canada. Both of these men would go on to make their own significant contributions to the young Dominion. George French would be given command of the Canadian Artillery's "A" Battery and the Kingston gunnery school, and he would later

be appointed as the first commanding officer of the North West Mounted Police (today's Royal Canadian Mounted Police).[12] Delroy Irwin would become French's second-in-command of "A" Battery and later given the overall command of the Royal Canadian Artillery before being promoted to the position of Adjutant-General of the Militia of Canada.[13]

After only ten months in the Academy's Theoretical Class, Gentleman-Cadet Carlile was promoted to the Practical Class where cadets received a further six months of hands-on instruction in military engineering, fortifications and artillery gunnery. After writing his final exams, Carlile graduated from RMA Woolwich, and on July 1, 1861, he was granted a commission as a lieutenant in the Royal Regiment of Artillery.

The Royal Artillery is the branch of the British Army responsible for all of the military's land-based cannons, carronades, howitzers and mortars, collectively known as artillery or ordnance. The longest artillery pieces, the cannons, are usually referred to as "guns" by the artillerymen, themselves referred to generically as "gunners". While any soldier in the Royal Regiment of Artillery could be referred to as a gunner, this was also the title used for the lowest ranking artilleryman, equivalent to a private in an infantry regiment.

The Royal Artillery of the 1860's was organised into several brigades, each of which performed one of three principle functions: they were either a Horse Artillery Brigade with their light cannons mounted on highly manoeuvrerable, horse-drawn carriages so that the guns, ammunition and gunners could be deployed very quickly to support the cavalry on the battlefield; or they were a Field Artillery Brigade, with heavier, longer-range cannons and ammunition wagons pulled by draught horses which followed behind the infantry and which were used tactically in battle to bombard enemy fortifications and troop concentrations; or they were Garrison Artillery manning the largest guns and mortars which were usually mounted permanently in fortresses, citadels and coastal forts positioned at strategic locations throughout the British Empire.[14] Brigades were commanded by a lieutenant-colonel, and most brigades were divided into eight units known as batteries.[15] Each battery was commanded by a major or captain assisted by a number of other officers who held the rank of second-captain or lieutenant. These officers were each responsible for a division of the battery which normally comprised three 10-man gun detachments consisting of the sergeants, corporals, bombardiers (lance-corporals) and gunners (privates) who maintained and fired the ordnance. Each garrison battery consisted of about 120 rank and file and up to five officers giving most garrison brigades a compliment of about 1,000 officers and men.

Upon receiving his commission, Lieutenant Carlile was ordered to join the 3rd Garrison Artillery Brigade. Typical of most Royal Artillery brigades, the 3rd Brigade included a considerable number of officers who had seen active service in the preceeding decade. More than a dozen had served with distinction in the Crimean War (1853-56) and in the Indian Mutiny (1857-58), and several others had seen action in the distant reaches of the British Empire including China, Africa, and the West Indies. Among them were also two officers who had been awarded Britain's highest military honour, the Victoria Cross.[16]

During the decade following the end of the Crimean War in 1856, the British Army was involved in no fewer than forty actions, campaigns, expeditions, conflicts and minor wars in such far-flung corners of the world as New Zealand, China, Burma, India and Africa. It was into this environment of never-ending skirmishes, battles and military victories "for the glory of the Empire" that Lieutenant Carlile proudly took up his role as an officer in the world's most active army.

Many of the newly commissioned officers from the Royal Military Academy must have been eager for an immediate posting to one of the Empire's hotspots with the hope of seeing action and achieving the fame and recognition sought by many Victorian soldiers, believing, as they did, in the words of the great patriotic English poet, Alfred Lord Tennyson, that, "The path of duty was the way to glory."[17] If Lieutenant Carlile were among those seeking immediate glory fighting in a foreign land, he might have been disappointed. After kitting himself out with the Artillery's distinctive royal blue uniform with its red trim and gold officer's braid, adorned with a regulation pattern artillery officer's sword and topped off by the standard "busby" fur hat (all purchased at his own expense), on August 1, 1861, he joined No. 5 Battery of the Royal Artillery's 3rd Brigade which was then in barracks at Woolwich, just a half-mile across Woolwich Common from the Royal Military Academy.

Any disappointment that William may have felt at such a mundane posting would have been short-lived as the 3rd Brigade had just received orders to proceed to the Mediterranean Sea. Eight days after reporting for duty, the entire brigade was inspected by Royal Artillery commandant, Major-General Sir Richard Dacres, then immediately transported down the Thames River on steamboats to board the troopship *HMS Himalaya* at Gravesend. After eleven long days at sea, the *Himalaya* steamed into the Grand Harbour of the island of Malta where batteries 1 through 5, including Lieutenant Carlile, were disembarked; the other three batteries remaining aboard to be transported to the Greek island of Corfu.[18]

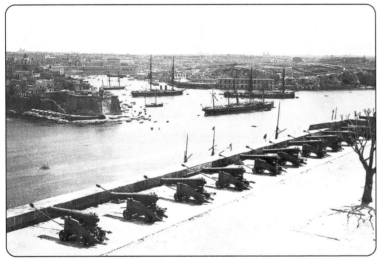

Photographer unknown, c.1870.
View of the Grand Harbour and Fort St. Angelo from the Saluting Battery.
Valetta, Malta,
[Courtesy of Fondazzjoni Wirt Artna, The Malta Heritage Trust.]

This photograph shows Malta's Grand Harbour as it would have appeared arround the time that Lieutenant Carlile arrived there in 1861.

Barely three weeks after joining his brigade, the newly-minted artillery lieutenant had arrived at his first garrison posting. There, he would live and work for the next six years.

Another British Army officer who had been posted to Malta several years earlier has left us his impressions of the island:

Malta is an extremely interesting little island, its extent about 170 square miles. Valetta, the town, is built on two sides of a hill, the principal street, Strada Reale, stretching along its apex. Those streets that run at right angles to it on either side are quite narrow and of a steep incline, the sidewalks consisting of innumerable steps. An almost unbroken line of shops extends from one end of Strada Reale to the other where an endless variety of articles are sold.

We disembarked on the same day we arrived, and were distributed at Florean Barracks, Fort Ricasoli and Fort Tigne.... Our mess of three [officers] was well supplied by our caterer at inexpensive rates. It is always excessively hot during the months of July and August, and a welcome addition to our daily fare was the profusion of fruit of various kinds with which our table was loaded. A remarkably nice light wine was also frequently in evidence with us, whether a native product or not, I do not know, but it resembled claret. When mixed with soda water, or better still fizzing lemonade with a lump of ice added, we found nothing better to allay that thirst

which under a blazing sun was, as it is said of the poor, always with us.

Each morning at five o'clock all hands bathed, and at six the fall in sounded for parade; a short affair, by the by, consisting only of inspection and marching off the guard. Thus for a time we had plenty of freedom.... One of us three, in our little garrison, was, according to general orders, to be found at his post at all times, so we took turns, one remaining on duty each day at the fort while the other two crossed over to Valetta to see friends, have a walk or ride in the country or perhaps dine at some other mess and go to the opera. The Opera House was a very large one, and well patronized during the season.[19]

Lying some sixty miles south of the Sicilian shores of Italy, the island of Malta had been occupied by the British since 1800, and it served as the Royal Navy's principal base in the Mediterranean Sea. Because of its strategic location, the island had been heavily fortified over the centuries. Not counting several ancient Bronze Age fortifications and numerous 17th Century fortified towers, there were eight substantial forts and more than seventy detached redoubts and gun batteries scattered in and around Malta's eight walled towns. Many of these fortifications, especially those situated in the vicinity of the principal town, Valetta, were armed with an extensive array of ordnance which became the responsibility of the five batteries of the Royal Artillery's 3rd Brigade.

Along with one or two other officers in charge of their own divisions, Lieutenant Carlile and the gunners under his command would have been stationed in one of the many forts which guarded the Grand Harbour and the Royal Navy dockyard. The officers' orders were to maintain discipline, maintain their guns and care for their gunners.

As the officer in charge of his division, Lieutenant Carlile would have been well versed in gunnery practice for large cannons such as 32-pounders and 68-pounders (so-called because of the weight of the solid cast iron cannon balls that they fired), and 8-inch, 10-inch and 12-inch shell guns (the size determined by the diameter of the exploding shells fired), as well as other ordnance such as carronades, howitzers and mortars and the variety of solid shot, case shot and Shrapnel shells used by each. However, unlike the Field Artillery which had just adopted the state-of-the-art Armstrong rifled breech-loading guns with their high rate of fire and exceptional accuracy, the Garrison Artillery was still using the outdated smooth-bore, muzzle-loading cannons that had changed little over the previous 200 years.

After six years of garrison duty on the small island, the 3rd Brigade received orders to proceed to British North America to exchange postings with the Royal Artillery's 10th Brigade. In June, 1867, half of the 3rd Brigade's eight batteries boarded the iron-hulled troopship *HMS Simoom*. After a 30-day voyage with several stops to refuel, three of the batteries disembarked at

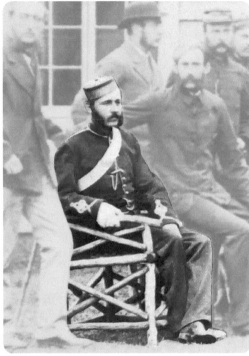

Photographer unknown, 1870.
R.A.(Royal Artillery) **and R.E.**(Royal Engineers)**, Quebec 1870.** (detail)
[From the collection of D.T. Irwin. Courtesy of the Irwin family, Ontario, Canada.]

This is the only known photograph of William Ogle Carlile, shown here seated among some of his fellow officers of the Royal Artillery and Royal Engineers.
(See the complete photograph on page 80).

Quebec City and went into barracks. No. 1 Battery was ordered to remain on board as it was to be disembarked at St. John's, Newfoundland.[20]

At the end of August, *Simoom* once again entered Malta's Grand Harbour where the gunners of the 10th Brigade duly relieved the 3rd Brigade's remaining batteries, including Lieutenant William Carlile. *Simoom* then re-embarked for Canada on September 1. Thirty-three days later, after making refuelling stops at Gibraltar, the Azores and Halifax, *Simoom* arrived at Quebec City on October 3, 1867.[21]

Arriving at Quebec City at the same time from Malta was the troopship *Himalaya* carrying the 1st Battalion of the 60th Regiment (King's Royal Rifle Corps). Together, the two ships disembarked the troops that would constitute the last cohort of Imperial soldiers to be sent to defend Canada.

Chapter 3

Carlile at Montreal and Ile aux Noix

After only a few days' rest in Quebec City, the newly arrived gunners were embarked aboard river steamboats destined for the two principle military stations further up the St. Lawrence River. Batteries 7 and 8 moved three hundred miles upriver to Kingston where they garrisoned Fort Henry, the Market Battery and other fortified posts. Batteries 5 and 6 only went as far as Montreal, where No. 6 Battery was relegated to the dismal fort on St. Helen's Island and No. 5 battery went into quarters at the city's Quebec Gate Barracks.

As British North America's military headquarters and Canada's largest city, Montreal afforded many social advantages to British Army officers stationed there. For these privileged few, life in Montreal consisted of rounds of receptions, parties, balls, picnics and sporting activities punctuated by occasional military exercises, parades and routine garrison duties. Lieutenant Carlile may have been looking forward to garrison life in the city; if so, he would have been disappointed. No. 5 Battery's commanding officer, Captain Reginald Farmer, immediately ordered William to take a detachment of twenty-three non-commissioned officers and gunners, along with their wives and children, and join a company of the Royal Canadian Rifle Regiment then in garrison at Fort Lennox, a strategic outpost on Ile aux Noix, a small island in the Richelieu River south of Montreal, just ten miles from the American border. There, Lieutenant Carlile was to assume the role of Officer Commanding, Royal Artillery.[1]

Just six weeks earlier, William had been 5,000 miles away enjoying fresh sea breezes under the hot Mediterranean sun. Now, with freezing weather quickly approaching in Quebec, he was about to experience his

first Canadian winter at this isolated post in the middle of an icy river thirty-five miles from Montreal where the rest of his battery would be enjoying the pleasures and pastimes of garrison life in the city.

For more than a century, Ile aux Noix had been an important military station, key to defence against attacks from the south. The island was first fortified by the French Army in 1759, during the Seven Years' War in North America, to protect the heartland of New France from invading British forces from the thirteen American colonies. This was a strategic point on the vital Lake Champlain/Richelieu River transportation route — to the south was the Hudson River and New York City; to the north was the St. Lawrence River with access to Montreal and Quebec City. In 1760, the British Army captured Ile aux Noix from the French, and three years later, at the end of the Seven Year's War, this island, along with much of New France, was ceded to Great Britain. In 1775, British engineers built substantial fortifications on the island after rebellious American colonists had used Ile aux Noix as a temporary base from which to launch attacks on Montreal and Quebec City at the beginning of the American War of Independence.

With the creation of the United States of America, many frontier outposts, like the one on Ile aux Noix,

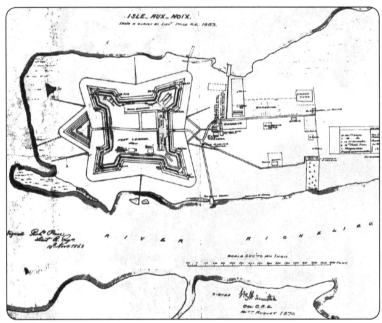

Lieut. Price R.E., 1863.
Ile aux Noix (Fort Lennox)**, from a survey.** (detail)
[Courtesy of Library and Archives Canada. H1/350/Isle aux Noix/1870, NMC15347.]

became the remaining British North American colonies' first line of defence against a possible future invasion from the south. When that invasion occurred during the War of 1812, the island's defences were strengthened. Fear of further attacks from the United States resulted in the construction of a completely new fort. Built in 1829, Fort Lennox could accommodate as many as six hundred soldiers in its handsome, stone barracks. By the 1860's, its proximity to the American border made this fort a key outpost to guard against attacks by the Fenian Brotherhood. As a result, it was one of the last detached stations to be abandoned by the British Army as its soldiers were eventually concentrated at Quebec City over the following years.

One advantage of William Carlile's eight-month stay at Fort Lennox was that this was his first independent command. He was the fort's Officer Commanding, Royal Artillery. Until he was relieved in June, 1868,[2] Lieutenant Carlile was responsible for all of the military and administrative matters pertaining to the gunners, artillery and ordnance stores at the fort, reporting only to the fort commandant, Captain Melville of the Royal Canadian Rifles. This experience, undoubtedly, would serve him well three years later when he would find himself in command of not just a detachment, but of the entire battery in the summer of 1871.[3]

We know little of William Carlile's day-to-day activities. If he kept a journal like many of his contemporaries, it has not come to light. From a copy of one letter preserved in the Canadian archives, we do know about one unfortunate and difficult matter that William had to deal with in the first weeks of his command at Fort Lennox: the death of one of his men, Gunner Henry Murphy, in October, 1867. There are no details of the cause of Murphy's death, but we do know that he was a family man; he had been accompanied to North America by his wife and their two children, both under ten years of age. On the gunner's death, his widow would no longer be entitled to any support from the army, so Lieutenant Carlile had to plead with his superiors to allow the family to continue receiving army rations until Mrs. Murphy and the children could be sent back home to England. It is not known what became of Mrs. Murphy and her children, but Carlile's request was granted and the gunner's family was allowed to draw army rations for another three months.[4]

When not occupied by his military duties, William spent much of his time painting and drawing around Ile aux Noix. One of the first pieces of his artwork to be published, a view of Fort Lennox, was produced at this time (see page 37).

OPPOSITE — William Ogle Carlile, c.1868.
Entrance to Fort Lennox, Ile aux Noix.
[*Canadian Illustrated News*, 4 February 1871.]

This scene was likely drawn in the spring of 1868 while William Carlile was stationed at Fort Lennox, but it was not published until 1871.

"Isle au Noix, in the river Richelieu, about nine miles from the American frontier, and fifteen miles from St. Johns, E.T. [St. Jean, Eastern Townships, Quebec], is considered a point of great importance for defensive purposes, especially in case the enemy had his base on our southern border. There is a fort erected on the island called Fort Lennox....

"Fort Lennox has barrack accommodation for six hundred men, and contains a large magazine, artillery, store-rooms, &c., &c. The fort is a square with bastioned fronts, surrounded by a wet ditch, and has two or three wells under it for the use of the garrison.

"Isle aux Noix, which is regarded by military men as capable of being made an important out-post in the defences of Montreal, is about two miles long, by three-quarters of a mile broad, and is generally rather low and swampy, though the cultivated portion is very fertile. The swamps are full of bitterns and water hens, and the island furnishes an excellent field for sportsmen, duck, snipe, cock, and plover being plentiful; while the angler finds in the surrounding waters an abundant supply of pike, black and rock bass, pickerel, perch, catfish, sunfish, &c. The scenery about and around the island is very picturesque."

[*Canadian Illustrated News*, 4 February, 1871, p. 66.]

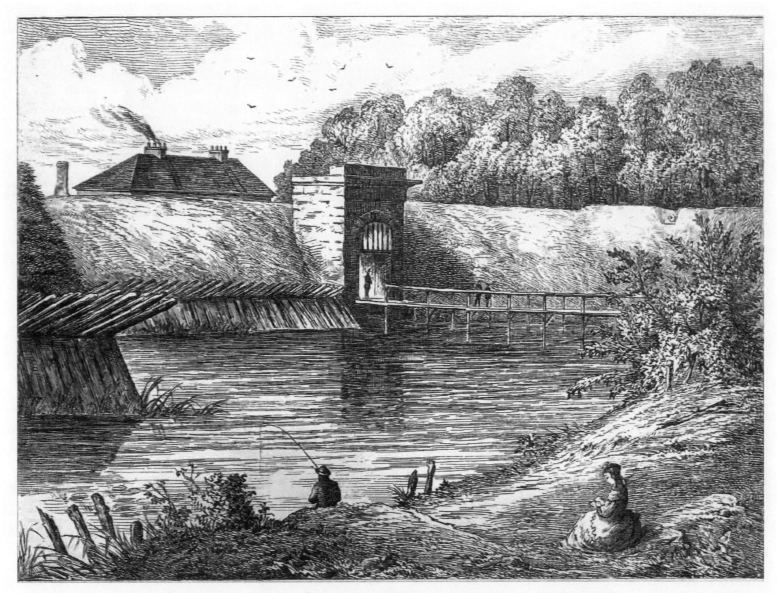

ENTRANCE TO FORT LENNOX, ISLE AUX NOIX. FROM A SKETCH BY W.O. CARLILE

In June 1868, a detachment of No. 6 Battery relieved Lieutenant Carlile and his men, who then returned to Montreal, the gunners being housed with the rest of No. 5 Battery at the city's Quebec Gate Barracks and their officer accommodated just across Dalhousie Square in rooms at the Royal Artillery officers' quarters. Now, for the first time since arriving in Canada, William was able to take part in the rich social life of Montreal.

That same year, an English tourist travelling through North America recorded his view of Montreal:

> The City of Montreal is beautifully situated upon the St. Lawrence, here more than a mile and a half wide, from whose banks it ascends to the wooded and rocky hill [Mont Royal] from which it obtained its modern name. It is in all respects a noble and beautiful city. Its streets are wide, and many of its shops and warehouses vie in size and architecture with the finest of those at New York, while in point of cleanliness no city in the United States, save, perhaps, Baltimore and some of the New England towns, can be compared with it. A magnificent quay, with well-built stone walls, extends the whole length of the city along the banks of the St. Lawrence, unmarred by the English and American selfishness of private wharfs. From this quay a fine view is obtained of the unrivalled Victoria Bridge above, and of the beautiful St. Helen's Island below, and of the wooded banks and distant mountains on the opposite side of the river.[5]

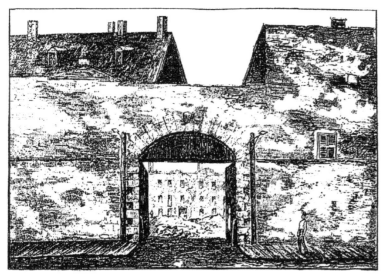

Artist unknown, 1881.
The Old Barracks in Montreal. (detail)
[*Canadian Illustrated News*, 2 April, 1881.]

A view of the Quebec Gate Barracks just before it was demolished in 1881.

The old city walls, originally erected by the French, had long since been demolished, leaving only a number of barracks in the city, and on St. Helen's Island, described by another Royal Artillery officer as a "miserable little island", where there was a small fort with its "decayed and trembling drawbridge" and "atrocious and weedy parapet".[6] This officer, Lieutenant Francis Duncan, who had several years of experience in North American garrisons, also made note of Montreal's other military facilities:

> The various barracks are commodious, although most of them are buildings hired and improvised for the purpose at the time of the "Trent" disturbance... but there is a considerable lack of accommodation for the officers ; so much so, that most of the regimental messes met at first in the various hotels in the city, while the members lived in lodgings....[7]

When Montreal was stripped of most of its garrison during the Crimean War, the social life in the city had suffered until the return of the British regulars in 1862, as a result of the "*Trent* Affair".[8] As in most garrison towns, British Army officers in Montreal made a significant contribution to life in the city, both socially and economically. The day-to-day lives of many of the officers in the colonies consisted of rounds of parties, balls, concerts and picnics as well as numerous sporting activities including cricket, horse racing, rowing, yachting and even fox hunting — the Montreal garrison at one time boasting the only pack of hunting hounds in North America.[9] Even the Canadian winters did not deter their outdoor social activities. Curling, ice hockey, skating parties, snowshoeing, tobogganing and sleigh riding were popular among the officers and members of the city's high society. In addition, many officers participated in community organizations such as the St. George's Society, St. Andrew's Society, Literary Society, Mechanics' Club and many others. All the while, the garrison officers also managed to perform their regular military duties.

It was likely that while stationed in Montreal William Carlile met the man who would soon begin to showcase his artwork to the Canadian public through the medium of magazine illustrations. This man was George-Edouard Desbarats, and the magazines were the *Canadian Illustrated News* and *L'Opinion Publique Journal Illustré*. Desbarats had been the official government printer in Ottawa since 1866. The following year, he formed a partnership with the engraver William Augustus Leggo with the idea that, together, they could produce a pictorial magazine that would sell all across Canada.

Leggo had recently invented the world's first commercially-viable halftoning process to allow photographs to be printed on a standard printing press. He called this process Leggotyping.[10] This was an electro-chemical engraving technique which converted a positive image into a negative which was then etched onto a metal

plate. The plate would then be mounted on a printing press to create a positive impression on paper.

With Leggo's invention and Desbarats' printing experience, the two entrepreneurs would soon launch the new magazines in Montreal. These would be Canada's first pictorial weekly publications and the world's first to use the patented Leggotype halftoning process.

Desbarats' vision for the *Canadian Illustrated News* was clear, but perhaps overly optimistic:

> A Canadian illustrated paper would be, as it were, a mirror that would reflect Canadian nature, enterprise and art throughout the world....
>
> By picturing to our own people the broad dominion they possess, its resources and progress, its monuments and industry, its great men and great events, such a paper would teach them to know and love it better, and by it they would learn to feel still prouder of the proud Canadian name.
>
> Therefore do we launch this important enterprise, and claim the cordial support, and energetic co-operation of all classes, creeds, and nationalities, in every portion of Canada.
>
> The *Canadian Illustrated News* will be published weekly, and will consist of sixteen large folio pages, printed in the highest style of art....
>
> A comic sketch may now and then rejoice the lover of ridicule, but never will our pages be disgraced by unbecoming or trivial prints....
>
> In time, we shall make every effort to exceed the expectations we have held forth, and to render the *Canadian Illustrated News* the favourite weekly for the whole Dominion by investing it with a high social and moral tone, making it a complete repertory of current events, and a record of the feelings and ideas of the times, worthy of the patronage of every family throughout the land....
>
> Contributions, literary and artistic, will be thankfully received and carefully considered, and if accepted and published, will be liberally paid for....
>
> GEORGE E. DESBARATS
> Publisher and Proprietor[11]

These magazines were to be the Canadian versions of the highly successful pictorials, the *Illustrated London News* from Britain, *Le Monde Illustré* from France and *Harper's Weekly* from the United States. Edited by Alexander Robertson, the first issue of 10,000 copies of the *Canadian Illustrated News* appeared on October 30, 1869, the front page displaying a Leggotype portrait of Prince Arthur from a photograph by noted Montreal photographer William Notman. This was followed, in January 1870, with the French-language version, *L'Opinion Publique Journal Illustré*. Edited by Louis-Olivier David, this magazine shared images with the *Canadian Illustrated News*, but it had separate editorial content.

Leggotyping was used to reproduce original photographs as well as photographic copies of European paintings that appeared in the two magazines. While all images

printed in the magazines were referred to as "Leggotypes", the copies of original artwork in the magazines' pages appear to have been created using the traditional technique of wood engraving. This technique relied on the engraver's skill to reproduce the lines of a work of art in relief on a block of wood. Some of the magazines' images may also have used a combination of the two processes; Leggotyping to capture fine detail on a copper plate which might the be manually enhanced by an engraver. The wooden block or the metal plate could then be mounted on a steam-driven printing press alongside the columns of lead type to make up each page of the magazine.[12]

To fill the pages of the new magazines with the promised illustrations, Desbarats solicited paintings and drawings from many of the prominent artists of the day including William Armstrong, Frederick Bell-Smith, Marmaduke Matthews, Henry Sandham and many others. Lesser known artists, including William Ogle Carlile, also had their artwork published in the pages of these two magazines.

By 1883, both magazines had ceased publication, but they had printed more than 15,000 images of original artwork by hundreds of artists. Among these were more than seventy-five illustrations by William Ogle Carlile, often identified only by his initials, W.O.C.[13]

The front page banners of the first issues of the *Canadian Illustrated News* (30 October 1869) and *L'Opinion Publique Journal Illustré* (1 January 1870).

G.W. Ellison, c.1865.
Sir George-Étienne Cartier.
[Courtesy of Musée National des Beaux-Arts du Québec, L'album Évêques, gouverneurs et hommes politiques du Québec, no.2006.3073.29.]

Canadian Minister of Militia and Defence, 1867-1873.

J.F. Large, n.d.
Edward Cardwell.
[From Robert Biddulph, *Lord Cardwell at the War Office*, London, 1904, p. ii.]

British Colonial Secretary, 1864-1866.
British Secretary of State for War, 1868-1874.

Chapter 4

The Final Decision

After the Dominion of Canada came into being on July 1, 1867, the first general election held in the new country saw Sir John A. Macdonald's Conservative Party form the government in Canada's first parliament. Prime Minister Macdonald then set about the task of turning the once separate colonies into a single, cohesive country; politically, economically and militarily. On the military front, the Minister of Militia and Defence, George-Etienne Cartier, announced that the government would table a new Militia Act in 1868 to consolidate the separate provincial militia systems and call for the establishment of a part-time Active Militia force. Up to 40,000 volunteers could be enrolled in any one of the various military units proposed by the legislation: cavalry troops, artillery batteries, engineer companies, mounted infantry companies, battalions or companies of regular infantry, or naval and marine corps. These citizen-soldiers would receive up to sixteen days of training every year. This force of volunteers could also be supplemented in time of war by a *levée en masse* of some 700,000 Canadians; every male between the ages of eighteen and sixty who would make up the Reserve Militia.[1]

Cartier introduced the new legislation in the Canadian House of Commons with his typical, eloquent rhetoric:

> This bill respecting the Militia and Defence of the Dominion of Canada is looked upon as necessary to complete our national system, as a Confederation....
>
> We had, in this Confederation, three elements necessary to constitute a nation — the personal, territorial and maritime elements — but when those three elements of national strength had been obtained there was still another necessary to crown the whole — the military element. (Hear, hear!) No nation on earth could pretend to be a nation *until it attained the military element, or the power of defence* [author's emphasis]....[2]

Similar to the militia legislation of the 1850's, this act made no provision for a regular, standing army of Canadian

Chapter 4

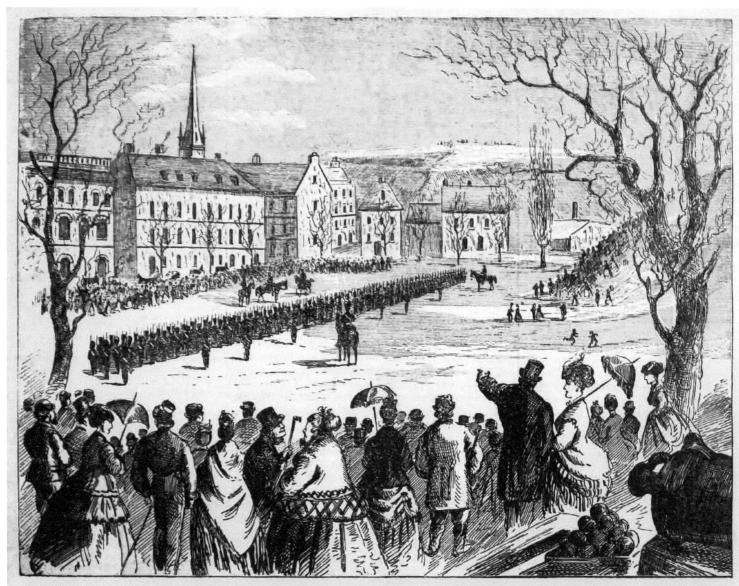

VOLUNTEER REVIEW AT THE ESPLANADE, QUEBEC. FROM A SKETCH BY W.O.C., LT. R.A.

44

professional soldiers. Instead, it continued to rely on part-time militiamen with minimal training to serve as auxiliaries to the British regulars.

After the Militia Act went into effect in October, 1868, Cartier journeyed to Britain as part of his government's delegation for face-to-face discussions with the new Liberal government of Prime Minister William Gladstone to finalize defence issues that had been left unresolved until after Confederation.[3] In London, the Canadians met with Edward Cardwell who was now the secretary of state for war, along with the new secretary of state for the colonies, Earl Granville. One of the objectives of the Canadian delegates was to confirm that the Imperial parliament would make good on its promise to guarantee another loan to Canada; this one amounting to £1.1 million to fortify

Montreal, with lesser works to be constructed at Saint John, New Brunswick, and at several locations in Ontario. This was to be Canada's share of the defence plan that had been agreed upon during the pre-Confederation meetings with the Imperial government. Britain's share included new forts at Pointe Lévis, then under construction to protect Quebec City.

The other objective was to ensure that any planned reductions of British troops in Canadian garrisons were minimized: "We deemed it our duty strongly to urge on Her Majesty's Government the necessity of keeping and maintaining in the Dominion as large a force of Her Majesty's Regular Troops as possible."[4] Such a statement from Cartier may be surprising given that, in his speech introducing the new Militia Act only a few months earlier, he had made the emphatic pronouncement about Canada needing to attain its own "power of defence".[5] However, neither Cartier, nor his government, nor most of the people of Canada wanted the British garrisons to leave.

This, perhaps, highlights the conflicting desires of many Canadians in the early post-Confederation years: Canadians wanted to maintain the Imperial connection, but they wanted their own country separate from British interference. They wanted to be able to defend themselves like every other nation, but they still feared the might of their American neighbours, so they desired the continued security (as well as the spinoff economic benefits)

OPPOSITE — William Ogle Carlile, 1870.
Volunteer Review at the Esplanade, Quebec.
[*Canadian Illustrated News*, 7 May 1870.]

The Militia Bill of 1868 provided for up to 40,000 volunteers to form the Active Militia of the Dominion of Canada.

"On the afternoon of the 23rd, the volunteers assembled at the ancient Capital were inspected by Col. Bagot of the 69th Regt., of which interesting proceeding we produce a Leggotype from a spirited sketch by Lt. W.O. Carlile, R.A."
[*Canadian Illustrated News*, 7 May 1870, p. 426.]

of having the British Army immediately at hand; a military force that provided a stable and experienced core around which the Canadian Militia could rally. It was not enough to have the promise of Imperial aid in the event of war, Canadians wanted British soldiers in the forts, ready to fight at a moment's notice.

While the British ministers acquiesced to the fortifications loan guarantee, they were unmoveable on the subject of troop withdrawals from North America, for Gladstone's government had already committed to a firm plan to reform the entire British Army, a plan that would greatly affect its overseas garrisons. Generally known as the "Cardwell Reforms", this was a series of measures implemented by Secretary of War Edward Cardwell to modernize the British Army.

Cardwell had experience dealing with the colonies as Britain's colonial secretary under the previous Liberal government of Lord Palmerston. With the Liberals back in power in 1868, Prime Minister Gladstone appointed Cardwell his secretary of state for war. Cardwell immediately set about making a top-to-bottom study of the British Army and determined to implement a number of significant changes. His reforms would include changes to improve the lot of the lowly British soldier; such as the abolition of flogging, the introduction of shorter terms of service, and less garrison duty at foreign stations, and they would put an end to the system of purchase of officers'

commissions and promotions. The most broad-reaching reforms, however, included the reorganization of Britain's War Office along with the reduction in the overall size of the army. This reduction would be accomplished largely by withdrawing thousands of troops from most overseas garrisons — especially from Canada — and concentrating them at home in the British Isles.[6]

In a letter from Cardwell to Colonial Secretary Lord Granville sent in January 1869, before the Canadian delegation returned to Canada, the secretary of state for war reminded his cabinet colleague of the long-held Liberal policy of colonial troop reductions going back to 1851, adding that...

> Very exceptional circumstances have no doubt prevented the application of these principles to the British North American Provinces during the last few years; but these circumstances have, in my opinion, ceased, and I am not aware of any sufficient reason which should prevent our returning to the policy laid down....
>
> I shall be glad, therefore, to be favored with your Lordship's opinion, whether it is necessary that any portion of Her Majesty's troops should be left in the Dominion of Canada, beyond such as it may be deemed expedient to retain with a view to the training of the militia and the volunteers....[7]

In presenting the 1869 military budget to the House of Commons in London in March, Cardwell spoke generally

of all of Britain's overseas possessions with specific references to Canada:

> The force in the colonies, according to the distribution on which the Estimates of last year were framed, consisted of 50,025 men [not including some 60,000 troops in India]; but, according to the distribution on which the present Estimates are framed, the force will consist of only 34,852 men, a reduction having been effected of 15,173....
>
> The principal change has occurred in Canada.... And here let me pause for a moment to ask whether this diminution of force is really any weakening of our colonies? In my opinion it is exactly the reverse....

Artist Unknown, 1870.
Mother Britannia says — "Cut her adrift eh! How dare you?"
[*Canadian Illustrated News*, 9 July 1870, p. 32.]

This cartoon shows British Prime Minister Gladstone cutting "Canada" loose from the British Empire, setting the new country adrift between two perils: complete independence from the British Empire and annexation by the United States. In the canoe, are Canadian Prime Minister Sir John A. Macdonald trying to find a safe course with his binoculars while three of his cabinet ministers wait for their orders.

If, instead of calling upon your colonists to exert themselves and to rely on their own resources, you distribute forces among them in small divisions, you will paralize their efforts without furnishing them with real strength. I believe that Canada, with 30,000 or 40,000 armed men of their own, occupies a stronger and more independent position than she ever did before.... and I believe that we shall be augmenting the power of England by encouraging in the colonies a spirit of self-reliance.[8]

It was left to Lord Granville to communicate to the Canadians the news that more than half of the British troops in the North American garrisons were to be sent home to Britain before the year was out. In preparing his dispatch to the new governor-general of Canada, Sir John Young, Granville was undoubtedly encouraged by the success of negotiations between Britain's foreign secretary, Lord Clarendon, and the U.S. ambassador to Great Britain, Reverdy Johnson, to quell American ill-will by settling the "*Alabama* Claims". The colonial secretary also believed that the Fenian threat to Canada was minimal and that future raids by them were unlikely.

His dispatch of April 14, 1869, was a blow to the Canadians. It indicated that not only would the number of British troops in Canada be reduced, but they would soon be withdrawn altogether, leaving the defence of Canada solely in the hands of the country's part-tim volunteer militia. Only Halifax would be designated an "Imperial station" (along with Bermuda, Gibraltar, Malta, and Hong Kong) where a small British garrison would remain to guard the naval base and dockyard of the Royal Navy:

Downing Street, 14th April, 1869

Sir. — Her Majesty's Government have had recently under their consideration the distribution of Her Majesty's Troops among the British Colonies, and the rate of contribution to be paid to the Imperial Exchequer by the Colonies in which they are placed.

As nearly one-third of these troops were till lately stationed in Canada, it need hardly be said that it became, in the first instance, necessary to consider what force should at present be retained in the Dominion, and on what terms....

Her Majesty's Government trust that the annoyance arising from the organization of Fenianism in the United States is fast disappearing. This organization, founded on the hostile feelings entertained by numerous Irishmen in the United States against Great Britain, derived its substantial importance from the circumstance that large armies had been recently disbanded, and were not yet thoroughly absorbed in the pursuits of peace. Such a state of things must always contain elements of danger to a neighbouring country, and so far as the Canadians suffer from it, they suffer not so much from their connection with Great Britain as from an unhappy — I hope a passing — accident of their geographical position....

The military and naval assistance hitherto given to Canada, under circumstances which they hope are now passing away, must at once be very largely reduced....

In the course of the summer, therefore, it is intended to withdraw from Ontario and Quebec, one Regiment of Cavalry, three Batteries of Field Artillery and three Batteries of Garrison Artillery, and three Battalions of Infantry, and from Nova Scotia and New Brunswick, two Battalions of Infantry and one Field Battery.

Halifax will be considered an Imperial Station and for its defence about 2,000 men will, for the present, be left in Nova Scotia.

About 4,000 men will, for the present, be left in Ontario, Quebec, and New Brunswick. But this must be considered a temporary arrangement, and I am disposed to concur with Mr. Cardwell in the opinion that ***it will soon become unnecessary to maintain any British force in those Provinces*** [author's emphasis], beyond what may be required for the training of the Militia and Volunteers....

I have further to point out to you that, in the opinion of the Secretary of State for War, any body of men, who are to be a charge upon the Imperial Exchequer, ought to be a body raised for the general service of Her Majesty, and not limited either by the conditions of enlistment or by practical necessity to a particular Colony. The Canadian Rifles [Royal Canadian Rifle Regiment] do not, as you are aware, satisfy this condition, and Mr. Cardwell is accordingly about to reduce four companies of

that corps, and to take measures to relieve the Imperial Treasury from the cost of supporting it. It becomes a matter for the consideration of the Local Government, whether that corps, or any part of it, useful as I believe it to be for local purposes, shall be maintained at the expense of the Colony....[9]

Not only did Granville under-estimate the will of the Fenians — they would execute further cross-border raids in 1870 — but unbeknownst to the colonial secretary, the day before he penned his dispatch to Canada, the U.S. Senate had overwhelmingly rejected the Johnson-Clarendon Convention, leaving the "*Alabama* Claims" as a significant source of potential conflict between the United States and Great Britain, with Canada caught in the middle. Furthermore, the dispatch announced that the Royal Canadian Rifles, a regular regiment of the British Army originally raised in 1840 strictly for service in Canada, would soon be disbanded.

By then, British forces in Canada had already been reduced by 3,500 rank and file to fewer than 13,000 soldiers (including a small number in Newfoundland[10]) necessitating a reshuffling of the troops remaining in the Canadian garrisons. Lieutenant Carlile and No. 5 Battery had already been moved from Montreal to Quebec City the previous November,[11] and by the spring of 1869, Cardwell's reduction of the Imperial garrisons in Canada was well under way.

There was much sadness among the local citizenry as the troops evacuated the far western posts at London, Ontario; Hamilton and Toronto.[12] Even a Toronto correspondent for *The Volunteer Review and Naval and Military Gazette,* a magazine whose editorial content was often slanted against the snobbish British officers, lamented, "The long talked of withdrawal of the troops from Canada will deprive us of the society of many gentlemen who have contributed not a little to the enjoyment of the citizens of this city."[13]

The headquarters staff of the Royal Artillery's 3rd Brigade was moved in June from Montreal to Quebec City. The batteries that had been stationed at Kingston soon followed.[14] The three batteries that had been in Quebec City since their arrival in 1867 were sent to Halifax to replace those that had been transferred to Bermuda and the West Indies. Most of the field artillery and several infantry regiments along with the only British cavalry regiment in Canada, the 13th Hussars, were ordered to embark for Britain aboard the troopships *HMS Serapis* and *HMS Crocodile.*[15]

By the end of 1869, the British regulars remaining in Canada for the general defence of the country would be limited to two batteries of field artillery, four batteries of garrison artillery, two companies of Royal Engineers, three infantry battalions, and eight companies of the Royal Canadian Rifles;[16] a total of fewer than 4,000 soldiers.

Canadians would have to accept that the Imperial government's decision was final. While all of the British troops defending Canada were slowly gathered at Quebec City to await their departure, it would still be two years before Canada reluctantly took full responsibility for her own internal military affairs.

OPPOSITE — William Ogle Carlile, 1870.
H.M.S. "Crocodile" at Quebec.
[*Canadian Illustrated News*, 23 July 1870.]

HMS Crocodile was one of the Royal Navy's purpose-built troopships used to transport soldiers to and from the many stations of the British Empire. This vessel, along with her sister ship, *Serapis*, had departed from Quebec City in May 1869, taking with them a large portion of the British garrison that had been defending Canada. Carlile pictures *Crocodile* here in July 1870, when the ship had returned to Quebec City to remove more troops along with Prince Arthur who had arrived in Canada ten months earlier.[17]

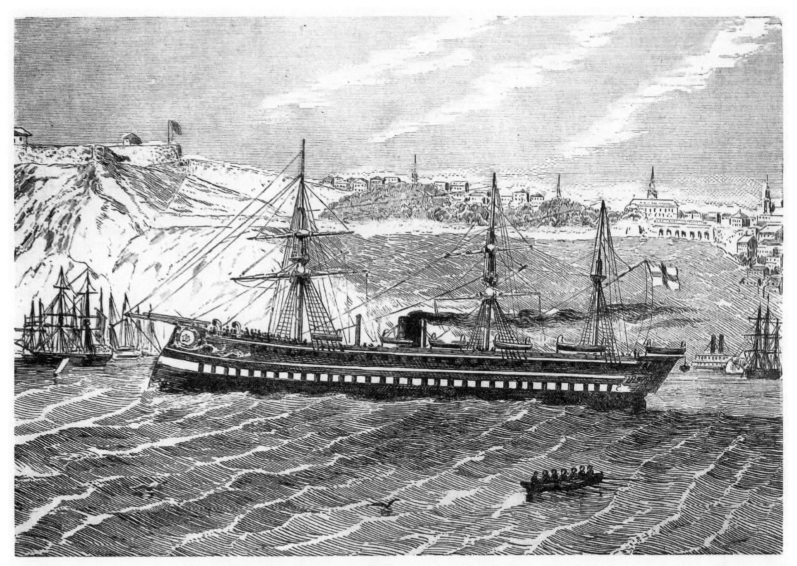

H.M.S "CROCODILE" AT QUEBEC. FROM A SKETCH BY W. CARLILE.

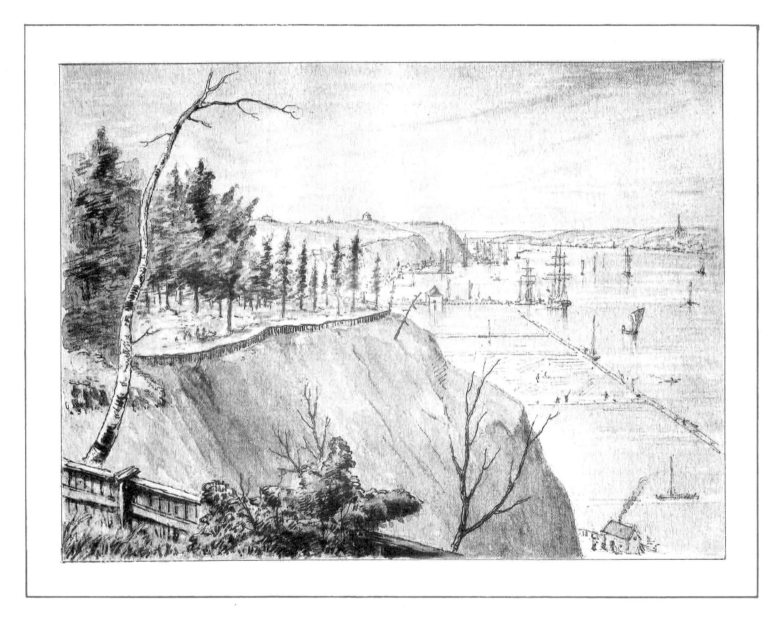

QUEBEC FROM SPENCER WOOD.

Chapter 5

Carlile at Quebec City and Pointe Lévis

In November 1868, several months before the British government announced its final decision to withdraw all of its troops defending Canada, No. 5 Battery had been ordered to leave Montreal. Lieutenant Carlile and his fellow gunners then found themselves aboard a river steamboat bound for Quebec City where the remnants of the British garrisons from the western posts were soon being concentrated for their withdrawal from Canada.

William arrived in the city right at the beginning of the busy winter social season. Ice skating parties, curling bonspiels, tobogganing outings, snowshoe picnics and sleigh ride excursions as well as the obligatory formal balls dominated Quebec City's social scene at that time of the year. Carlile was particulary interested in illustrating winter activities, and these are very prominent among his works presented in the news magazines and in his book, *Recollections of Canada*, which he compiled with Lieutenant-Colonel B.H. Martindale a few years later.

It their book, Martindale offered this description of Quebec City:

> It has been our fate to wander round the world, and to see some of the fairest scenes.... But with the exception of two or three, which are set in our memory as pictures unapproachable in grandeur

OPPOSITE — William Ogle Carlile, c.1870.
Quebec from Spencer Wood.
[From *Recollections of Canada*, London, 1873.]

This is a view down the St. Lawrence River which William Carlile would have seen on his return to Quebec City from Montreal in 1868.

"Looking east from Spencer Wood, one just catches the points of Levis and the Isle of Orleans.... Between Spencer Wood and the north shore opposite the Island of Orleans, lies Quebec.... Under the heights of Spencer Wood, and between it and the Citadel, is where Wolfe landed and above are the Plains of Abraham; and all along this and the opposite shore of Levis are the vast lumber yards of Quebec."
[B.H. Martindale, *Recollections of Canada*, London, 1873, p. 51.]

or in beauty, we have never seen anything that sat-
isfied us more than dear old Quebec....

There are the Citadel and Barracks; and the
old flag-staff; and the ever-beautiful mountains
and hills, and valleys and plains, and rivers and
island; and the busy bustling town; and the
heights of Spencer Wood with the lumber-yards
beneath; and the French and English cathedrals;
the Laval University; the Custom-house; the
Queen's Wharf, where so many a regiment and
such myriads of military stores have been em-
barked and disembarked....[1]

More than half of Carlile's twenty-five illustrations
that appear in *Recollections of Canada* are winter scenes,
many of which depict the officers of the Quebec garrison
enjoying the many off-duty pastimes in and around the
city. Four of these scenes are included here.

OPPOSITE — William Ogle Carlile, c.1870.
Toboganning.
[From *Recollections of Canada*, 1873.]

"The tobogan... is to the sleigh what the horse is to the pony. It varies
somewhat in length and breadth, but is usually made of a piece of ash,
about nine or ten feet long, eighteen inches wide, and a quarter of an
inch thick. It is as smooth as glass on the under side, and rolled up at the
front, where the wee bit of rope runs through to drag it by. Yes, three can
go in it, but two are the more usual number. Those three are Miss ____,
and Miss ____, and young Carlile. You notice that the first is sitting with
her feet inside the roll in front, the second close behind her, and Carlile is
lying down behind her again; he is steering with his foot....

"Where the gentleman is sitting down in front, and the lady is stand-
ing up, are Colonel and Mrs. ____. Standing on the toboggan she will
take you down a bank that many a brave man unused to the thing will
wink at when going down it sitting."

[B.H. Martindale, *Recollections of Canada*, p. 27.]

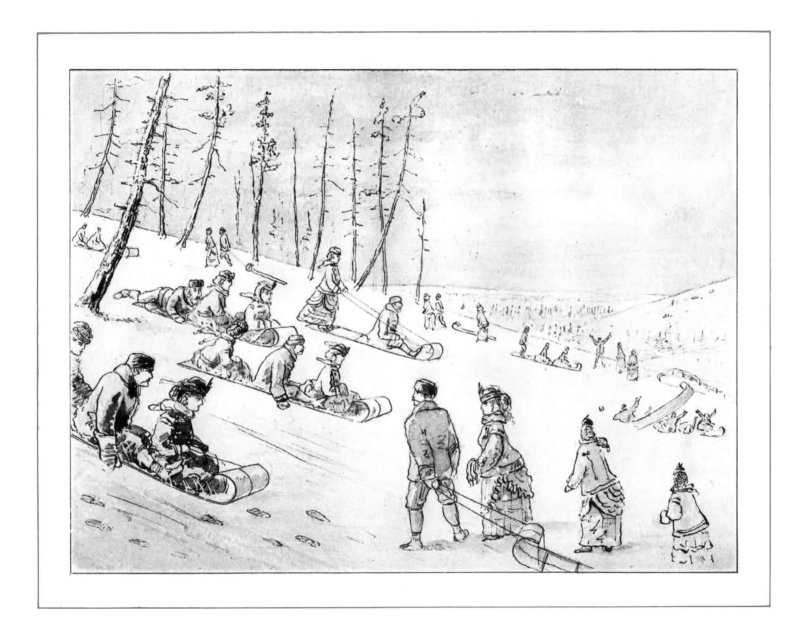

TOBOGANNING.

OPPOSITE — William Ogle Carlile, c.1870.
Tandem Club.
[From *Recollections of Canada,* 1873.]

"There are fifteen tandems out to-day. What a pretty sight it is in this sunshine, and with this fresh keen *air,* not *wind.* You may go far and not see so many sleighs together so well built and horsed, and with such robes and furs, to say nothing of the 'get-up' of the Club, and of the ladies they are driving. The robes just touch the snow behind; and it is next to impossible for any cold to get through those furs when wrapped round you '*à la Canadienne.*' How handsome those fur coats and cloaks are, and how very becoming the clouds[hoods], though they will permit but little more than the lady's eyes to be seen. This is the really national costume of Canada."

[B.H. Martindale, *Recollections of Canada,* p. 30.]

TANDEM CLUB.

OPPOSITE — William Ogle Carlile, c.1870.
Snowshoeing.
[From *Recollections of Canada*, 1873.]

"Snowshoeing must take its place with sleighing and skating, among the amusements of a Canadian winter, and there are snow-shoe clubs which execute marvellous feats in the pedestrian way. It is useful, however, as well as enjoyable, and it is surprising how far, without fatigue, men and women will in snow-shoes walk over a surface which they could in no other way traverse at all.

" 'Come away,' said Carlile to me one morning; 'we are going to Gomin Wood — snow-shoeing party.'...

"The party to Gomin are all old hands, judging by the quiet facile way in which they are coming through the wood. The snow is in excellent order, neither too hard nor too soft, and there is plenty of it, indeed, for it spreads around far as the eye can see, and is of unknown depth in places....

"I see some quiet fun of another sort going on. The party are not all together; some couples have loitered a little behind, and are talking of — well, of those things which young people do talk of, when they pair off and think that there are no people in the world but themselves, whether at a pic-nic, or sleighing, or in the ball-room, or snow-shoeing."

[B.H. Martindale, *Recollections of Canada*, p. 44.]

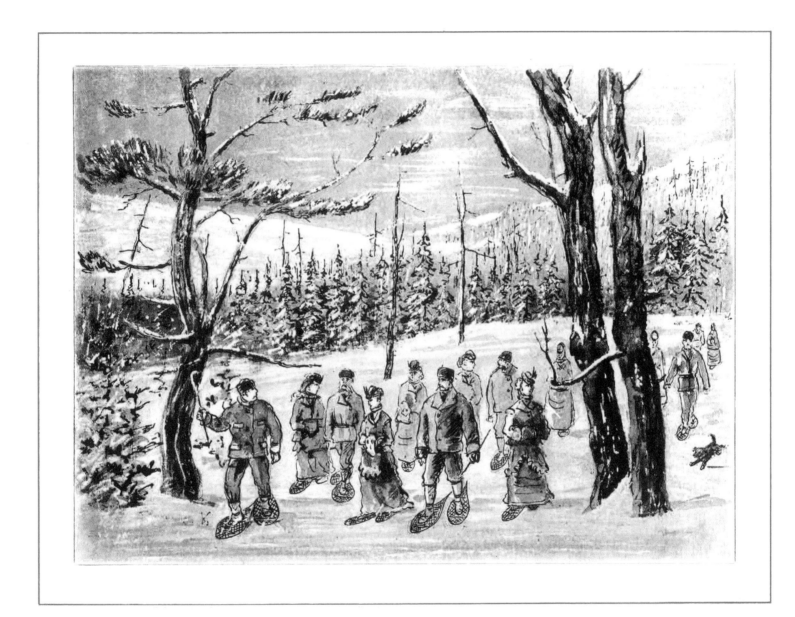

SNOWSHOEING.

Many young ladies from Quebec City's finest families attending these social gatherings did so hoping to find a wealthy husband among the garrison officers. The officers, in turn, were only too happy to flirt with and even court these eligible prospects, but marriage was often discouraged by the military authorities. Any soldier who wanted to marry a local girl would need the permission of his commanding officer, and many a young subaltern had been prematurely sent back to Britain in order to get him out of a romantic situation.

Captain Richard Dashwood, who spent several years in North America with the 15th Regiment, commented on the subject:

> The withdrawal of troops from Upper and Lower Canada [Ontario and Quebec] will cause an unprecedented fall in the matrimonial market of those sections. The loss of so many bachelors in the shape of the officers of the army will be severely felt. Canada has proved more fatal to celibacy than any other country where troops are stationed, including even England....
>
> A young and not over wise man meets a lady at the skating rink, who rather takes his fancy; she seeing at once that an impression is made, meets him quite half way, often more so. Day by day, hand in hand, they glide round the icy circle.... In the end he is often secured, as tight as a sable in a dead-fall, unless he is suddenly ordered away, or goes on leave. Some commanding officers, when any officer of their regiment got "severely wounded", sent him away on leave....[2]

Dashwood's remarks were quantified by another writer who tallied up all of the British officers' weddings in Canada recorded between 1869 and 1873. This amounted to 149 marriages of Canadian girls to officers in thirty-five different regiments;[3] representing approximately ten percent of all of the officers stationed in Canada in that period.

OPPOSITE — William Ogle Carlile, c.1870.
Skating in the Rink.
[From *Recollections of Canada*, 1873.]

"When it's *à poudré*, or too cold to drive or even walk, or is blowing, or one has nothing better to do, or wants exercise, or oh! above all when 'the band plays,' the Rink becomes the centre of attraction.

"It is not a handsome, nor in itself a particularly cheerful building. On the contrary, it resembles a long, rather low barn, with windows at both sides and skylights in the roof, dressing-rooms for ladies and gentlemen on either side as you enter, and at the opposite end a sort of chancel for the band with a stove in it. But the floor is a lovely sheet of clear pure ice, round which at about fifteen inches or so above the ice runs a wooden platform five or six feet wide, with seats at intervals. From the roof descend gaslights, for the rink is usually kept open till nine or ten o'clock at night....

"The bands, except on special occasions, such as a fancy dress carnival, play in the afternoon. Then is the time to see what finished skating is, and to be convinced that there are no movements in the world more exquisitely graceful than those of accomplished skaters.... It is perfection of human motion....

"Glance under the windows and along the platform, and you will catch quite a different phase of the rink.... Ah! was there ever any quiet shrubbery, or moonlit lane, or ball-room recess, better fitted than the rink for the recounting all the past, the enjoying all the present, the making 'engagements,' less or more serious for the future...."

[B.H. Martindale, *Recollections of Canada*, 1873, p.36.]

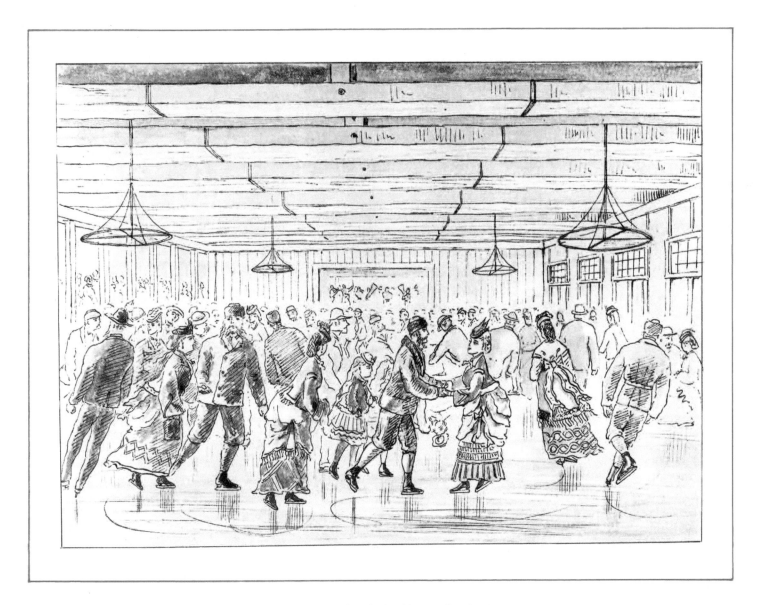

SKATING IN THE RINK.

At one of these many social functions, William met Miss Rachel Louisa Phillips, the daughter of the late Quebec City businessman, William Phillips. The couple began courting and it's possible that some of Carlile's paintings and drawings depicted Louisa enjoying the pleasures and pastimes of Quebec with him.

At thirty years of age, William was likely not a starry-eyed suitor, so when he eventually asked his commanding officer for permission to marry Miss Phillips, his request was granted. Just eleven weeks before William was to leave Quebec City with the last Imperial garrison, he and Louisa were married on August 26, 1871, at Christ Church in the village of Valcartier, some fifteen miles north of the city[4].

While there were always numerous social activities in Quebec City to occupy an officer's off-duty hours, the arrival of Prince Arthur in 1869 had added many more events to the already busy social calendar. Unlike his brother's visit to North America nine years earlier, Arthur came to Canada, not on an official royal tour, but as a soldier who had been posted to his regiment, the Rifle Brigade[5], then in garrison at Montreal. Arthur was Queen Victoria's third son and fifth in line to the throne. The prince had attended the Royal Military Academy at Woolwich and was initially commissioned in 1868 as a Second Lieutenant in the Royal Engineers before transferring to the Royal Artillery and, subsequently, to the Rifle Brigade.

While Prince Arthur's formal military duties in Canada were limited, he was involved in many military ceremonies; royal inspections, reviews and presentations of colours, and he was always the guest of honour at military balls and other social gatherings in Montreal and Quebec City.

OPPOSITE — William Ogle Carlile, 1870.
Ball Given By the 69th Regiment at Quebec.
[*Canadian Illustrated News*, 16 July 1870.]

Prince Arthur is the figure to the right of centre in the dark uniform of the Rifle Brigade. The handsome couple to the left of centre could be the artist himself, accompanied by Miss Rachel Louisa Phillips.

"Wednesday, the 21st of June, was a gala day in the ancient capital on the occasion of the presentation to the 69th Regiment of a new set of colours. The ceremony was performed by H.R.H. Prince Arthur with great *éclat*, and was followed in the evening by a ball given by the citizens in honour of the regiment....

"The day's proceedings terminated with a ball at the Music Hall, which on this occasion proved a little small to accommodate the large number of invited guests.... The Prince, whose movements were closely watched with interest, wore the usual full-dress uniform of an officer holding his rank in that branch of the service to which he belongs. The brilliant scarlet of the Royal Engineers and soldiers of the line stood out in rich relief to the more sombre tunic of the Artillery and Rifle Brigade..... the ladies chiefly appeared in light fabrics of various patterns, trimmed in the richest and most varied style. The assemblage in every particular presented an appearance which will be long remembered by all present."
[*Canadian Illustrated News*, 16 July 1870, p 34.]

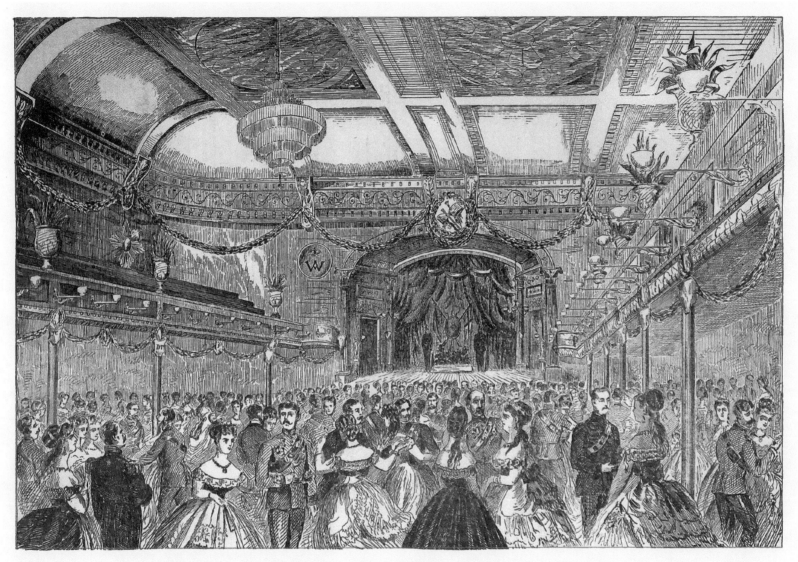

BALL GIVEN BY THE 69TH REGIMENT AT QUEBEC. FROM A SKETCH BY W. CARLILE.

William Ogle Carlile, 1871.
My New Year's Day Experience.(detail)
[*Canadian Illustrated News*, January 14, 1871.]

This is one of nine images from Carlile's comic strip in which he lampoons his own social outing on New Year's Day, 1871.

Among his other artistic talents, William Carlile was also an accomplished cartoonist. More than ninety of his cartoons are known to have been published.[6]

Comic art had been well known in Britain since the early 18th Century. Noted artists such as William Hogarth and Thomas Rowlandson were appreciated for their humorous drawings, paintings and etchings. In 1841, the satirical British magazine, *Punch,* was first published and it contained numerous cartoons, mostly political caricatures, in every weekly edition.[7] Recognizing the popularity of these comic images, the *Canadian Illustrated News* included a cartoon in many of its issues.

The favourite subject of William Carlile's humorous sketches was the fictional character, Young Downylip, the awkward junior officer who had just arrived at his first posting in Canada. Through the Downylip character, Carlile was, most likely, simply lampooning himself and his own experiences in Canada. Not above portraying himself explicitly in cartoons, his own "New Years Day Experience" in 1871,was also published in the *Canadian Illustrated News*.

OPPOSITE — William Ogle Carlile, c.1870.
Young Downylip's First Visit to Canada. (composite)[8]

This is a compilation of a number of Carlile's cartoons from eight separate issues of the *Canadian Illustrated News*. Here is Colonel Martindale's comment on Young Downylip:

"He came out rather late in the season, about the end of December, by way of Portland. A nice, good-looking youngster; but as ignorant of Canada as any one well can be"
[B.H. Martindale, *Recollections of Canada*, London, 1873, p. 38.]

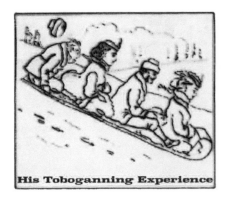

His Toboganning Experience

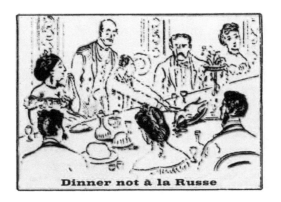

Dinner not à la Russe

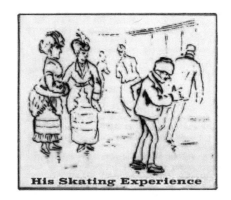

His Skating Experience

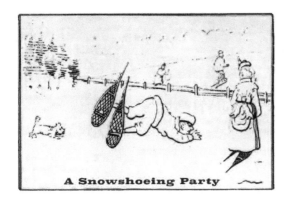

A Snowshoeing Party

~ At an Evening Party ~

A Few Street Adventures

His Curling Experience

Young Downylip's
First Visit
to
Canada

by
W.O.C.

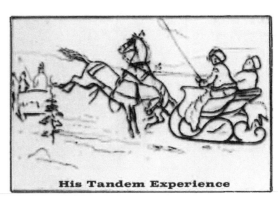

His Tandem Experience

The officers of the garrison also involved themselves in the cultural life of Quebec City. Many were active participants in amateur theatrical productions and several, including William Carlile and his friend, Delroy Irwin, joined the Quebec Literary and Historical Society.[9]

Even though the pleasures of Quebec City occupied much of the garrison officers' leisure time, there were still military duties to perform. In accordance with *The Queen's Regulations and Orders for the Army*,[10] all officers were required to inspect the men under their command each morning and each evening. On a rotation basis, an "officer-of-the day" in each regiment would be responsible for overseeing the sentries and supervising the distribution of rations in the soldiers' messes. Other officers might be required, from time to time, to undertake general garrison duties around the city such as commanding fatigue parties assigned to perform maintenance of the barracks and fortifications. Outside of these occasional duties, the officers would be free to pass their time as they wished.

Over the course of the three years that Lieutenant Carlile was stationed at Quebec City, he depicted several scenes illustrating soldiers on duty. Two of his garrison scenes of winter military activities were published in both *L'Opinion Publique* and in the *Canadian Illustrated News* (see opposite and page 69).

OPPOSITE — William Ogle Carlile, 1871.
The Coldest Sentry Walk in the British Empire.
[*Canadian Illustrated News*, 18 March 18 1871. Published as "Poste Militaire le Plus Froid de l'Empire Britannique sur la Citadelle, Quebec" in *L'Opinion Publique*, 16 March 1871.]

"Our special artist at Quebec conceives that the ancient Citadel furnishes the 'coldest sentry walk in the British Empire.' Perhaps he is right.... The citadel of Quebec is, undoubtedly, a cold place in winter. Its great elevation above the level of the surrounding country makes it especially cold in winter. The point sketched is near the 'Hog's back,' a very cold spot certainly, where the wind, from every point of the compass, has full play. In very severe weather, the military authorities relieve sentry every half hour, and, which is rare, when the thermometer gets lower than thirty degrees below zero [Fahrenheit], the sentry is withdrawn altogether. The magazine which is thus guarded is of considerable importance, containing large quantities of gunpowder, &c. The sketch represents a sentry of the 60th Rifles on duty."

[*Canadian Illustrated News*, 18 March 1871, p. 178.]

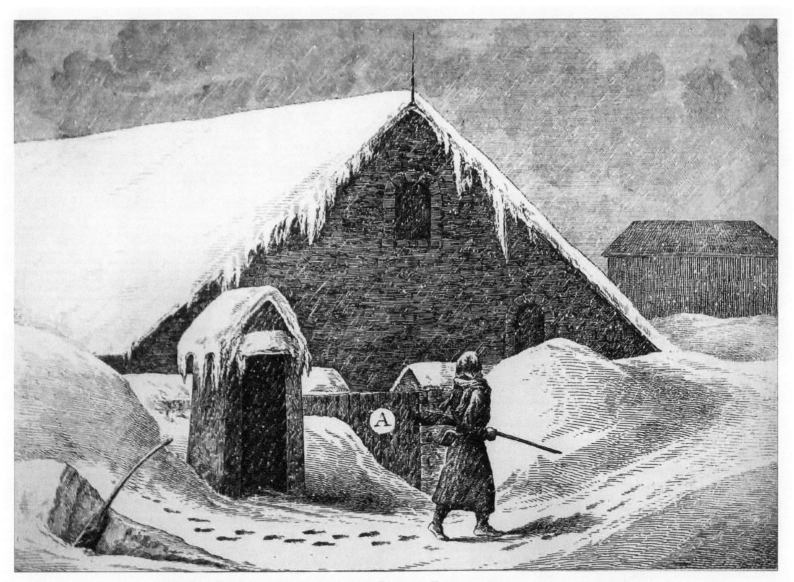

THE COLDEST SENTRY WALK IN THE BRITISH EMPIRE. FROM A SKETCH BY W.O.C.

Chapter 5

OPPOSITE — William Ogle Carlile, 1871.
Clearing the Snow from the Ramparts, Quebec.
[*Canadian Illustrated News*, 14 April 1871.]

"The little garrison still remaining at Quebec, having no more desperate enemy to deal with, frequently engage with the snow that accumulates on the ramparts, and our special artist, W.O.C., has sent us a vigorous sketch of the manner in which this bloodless warfare is carried on."

[*Canadian Illustrated News*, 14 April 1871, p. 211.]

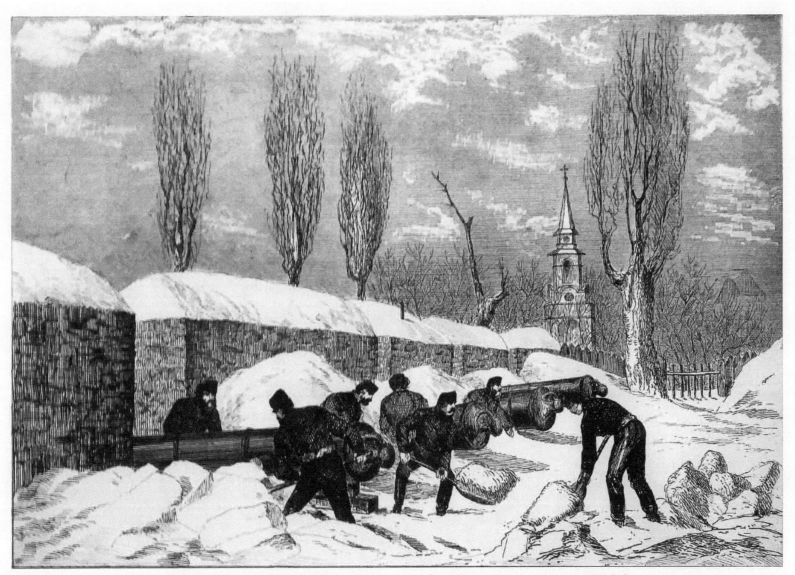

CLEARING THE SNOW FROM THE RAMPARTS, QUEBEC. FROM A SKETCH BY W.O.C.

In addition to their military duties, the soldiers of the garrison were also called upon, on occasion, to aid the civil power by helping to suppress riots and to fight fires.[11] By the middle of the 19th Century, many Canadian towns and cities had their own police force ranging in size from one man to several uniformed constables who would patrol the streets and arrest anyone suspected of theft, brawling, public drunkeness or other minor crimes. These forces, however, were entirely inadequate if required to suppress large riots such as those which frequently occurred during elections, or between rival Irish Catholics and Protestants, or other civic disturbances. In such cases, the local garrison could be called out on the writ of a magistrate to help restore order.

In Quebec City, one such situation arose after the civic election in May, 1870. The defeated mayor and city councillors had barricaded themselves inside the City Hall, so soldiers of the 69th Regiment had to be called out to help keep the peace. William Ogle Carlile was on the scene to record the event for the *Canadian Illustrated News.* [12]

Fighting fires was also a frequent activity of garrison soldiers. As fires in urban areas were always a serious threat, local fire brigades were formed, but they often required the aid of the military to help fight fires that were raging out of control and threatening to destroy large residential areas of Canadian cities. Quebec City was the scene of several of these catastrophic fires during the 19th Century. One of the worst, in 1866, was a fire in the St. Roch suburb that claimed the life of a Royal Artillery officer, Lieutenant Henry Edward Baines.[13] In 1870, Carlile depicted a scene showing another fire in the same vicinity which caused substantial damage (opposite).[14]

OPPOSITE — William Ogle Carlile, 1870.
Great Fire at Quebec, May 24th, 1870.
[*Canadian Illustrated News*, 4 June 1870.]

"The ancient capital has been the scene of another terrible conflagration, by which upwards of four hundred houses have been burned. The fire broke out about one o'clock on the morning of the 24th May, in a house at the corner of Crown and King streets in the very centre of St. Rochs suburb. A strong easterly gale blowing at the time carried the flames with great rapidity to the adjoining houses, and it soon became evident that an extensive conflagration must ensue, and a general panic prevailed amongst the people, who anticipated a repetition of the sad disasters which had on former occasions devastated this portion of the city....

"The fire then crept stealthily along the mass of wooden dwellings and out-houses along Ann and Richardson and other streets, toward the extensive ship-yards of Mr. Baldwin, on Prince Edward Street, where two large ships in course of construction under cover of an immense wooden shed were speedily consumed....

"The firemen aided by the Artillery and the 69th Regt., under Cols. Chandler and Bagot, at length succeeded in circumscribing the fire, and by six o'clock it was thoroughly got under, after some five thousand people had been rendered houseless....

"Our illustration, from a sketch by our special artist, represents the conflagration, as it was nearing Mr. Baldwin's vessels."

[*Canadian Illustrated News*, 4 June 1870, p. 487.]

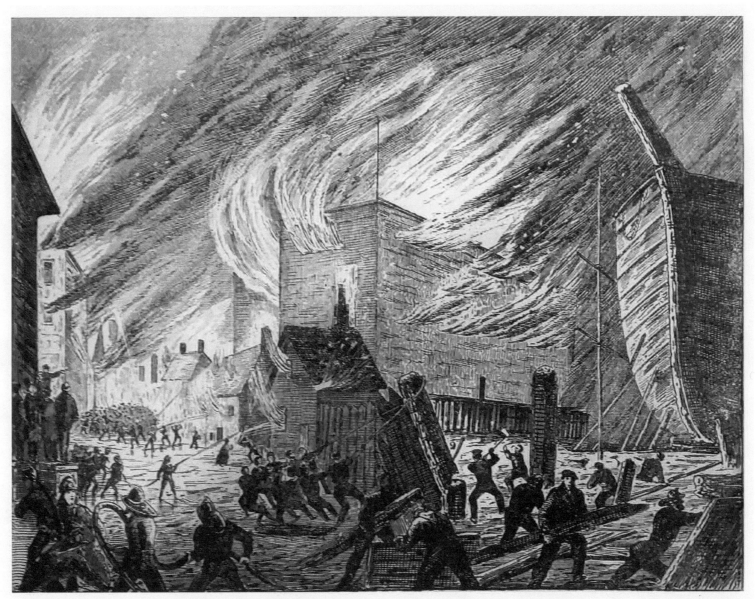

GREAT FIRE AT QUEBEC, MAY 24TH, 1870. FROM A SKETCH BY W.O.C.

Meanwhile, across the St. Lawrence River from Quebec City, at Pointe Lévis, the Royal Engineers were coordinating the construction of a series of new forts designed to help strengthen the city's defences.

Originally built as a walled town during the French Regime, the fortifications of Quebec City had gradually been improved under the British. A series of Martello towers had been built prior to the War of 1812 to protect the western approaches to the city, and a large fortress, the Quebec Citadel, was constructed in the 1820's on Cape Diamond, the promontory dominating the city and the river. By the 1860's, however, these defences had become largely outmoded due to advances in artillery technology.

To enhance the city's defences, construction of a series of modern forts on the height of land beyond Pointe Lévis had begun in 1865. This was part of a broader fortification plan that was intended originally to place the Province of Canada, and later, the Dominion of Canada, in a better defensive position and to provide secure bases for the British troops and Canadian Militia in the event of war with the United States.

The first comprehensive review of the defence of British North America had been ordered by the Duke of Wellington in 1819, and then again in 1825,[15] but it was not until the threats that arose as a result of the American Civil War that the defence of the colonies was reassessed in any detail. In February 1862, at a point early in the war when some military observers in Britain believed that the once powerful United States were in a "diminished condition",[16] a six-man defence commission was appointed by the governor-general, Viscount Monck. In September, the commission reported:

> That fortified places are necessary for the defence of Canada is a principle that has long been conceded and acted upon, as is shown by the construction of fortresses at Quebec and Kingston, and of smaller defensive works at other important points.... For these reasons, Your Commissioners recommend—
> • The improvement of the fortifications for Quebec.
> • The construction of defensive works at certain points... both to guard the frontier and for the safety of the navy, and the erection of fortified places in the several military districts.... on a sufficient scale to cover the magazines of arms, ammunition, and stores which each district should possess; to serve as rallying points for the Militia and other forces, and as bases of operations upon which the troops could retire, in case of being driven from the field.[17]

The estimated cost of these permanent fortifications, together with new naval dockyards on the Great Lakes and temporary works erected in time of war, amounted to £1,611,000, not including the cost of 466 artillery pieces. Of this, £50,000 was estimated for a fort at Pointe Lévis,

"an enclosed work to be constructed on the high ground to the south of Point Levi church to mount 20 guns and with accommodation for 500 men, for the purpose of preventing the enemy occupying this ground".[18]

By the following autumn, the fortunes of war were turning in favour of the Union Army. The Confederates had been defeated at a number of key battles including Antietam and Gettysburg, and the siege of the Mississippi River stronghold at Vicksburg had ended in a Union victory. Fearing that a total collapse of the Confederacy might encourage American politicians to turn the one million strong U.S. Army against British territory, the Liberal government in Britain, still mindful of the policy of reducing the colonial garrisons, now asked for a new assessment of the means and cost of defending the Province of Canada. The assistant inspector-general of fortifications, Lieutenant-Colonel W.F. Drummond Jervois of the Royal Engineers was sent to British North America in 1863 to recommend a practical plan to defend the colonies. In his report of February 1864, in addition to recommending improvements to the defences of Bermuda and Halifax (both important bases for the Royal Navy), he advised that, in the event of war with the United States, all British troops should be withdrawn to new fortifications to be built at Montreal and Quebec City, stating that, without a strong naval force on the Great Lakes, "it would be impossible to suggest any plan for the defence of Upper Canada".[19]

The idea of abandoning the entire western portion of the Province of Canada in the event of an American invasion was shocking to Canadian politicians. When Colonial Secretary Edward Cardwell had asked to meet with a delegation from the province to discuss defence matters in detail, the Canadians first asked that Jervois return to North America and reassess the situation since, "now... the Government of Canada contemplate making provision for a fortified harbour and naval Establishment at Kingston, with a view to a Naval force being placed on Lake Ontario for the protection of the western districts."[20]

As a result, in his second report on the defence of Canada, submitted in November 1864, Jervois's new plan included provision for fortifications at Toronto and Hamilton and for improving the defences of Kingston. However, Montreal and Quebec were still considered to be the most important strategic points for the defence of the colony. Jervois estimated that the cost of his plan would be £1,754,000.[21] This amount included £200,000 for new fortifications both at Quebec City and across the river at Pointe Lévis:

> The existing fortifications of Quebec, which are entirely on the left bank of the St. Lawrence and the St. Charles rivers, consist of an enceinte round the old town, with a citadel at the south-west angle.... Excepting the citadel, the existing fortifications of Quebec are scarcely capable of defence.

The attack upon Quebec which is most to be feared is that of the enemy advancing from the direction of Richmond [the main rail junction ninety miles south-west of Quebec City] and establishing himself on the ground opposite the town, on the south side of the river at Point Levi, which he can reach without crossing the St. Lawrence. In possession of that point he would command the harbour and prevent reinforcements being thrown into Quebec thereby, or the retirement of the forces therefrom. A permanent defensive position should therefore be established at Point Levi, to prevent the enemy obtaining possession of that ground. This position, which is about three miles long, should be occupied by detached works, and within it, on the banks of the river, some heavy guns should be placed to co-operate with the batteries of the Town in the defence of the channel. The Citadel of Quebec will form a keep to the whole.[22]

In January 1865, Cardwell had advised Governor-General Viscount Monck that the British government was going ahead with the fortifications at Quebec City as recommended by Jervois, and he reminded the governor-general that the Province of Canada had also committed to build the required fortifications at Montreal and beyond:

Her Majesty's Government... cannot forget the very small proportion which the numerical strength of the British Troops on the North American Continent bears to the Force [in the United States of America} which might at any moment be

broutght into the field against them. It would be a cause of just reproach against the British Government if those Troops were suffered to remain in a position which, on the outbreak of war, they might not be able to hold until the military and naval resources of the Country [Great Britain] could be made available for their support.

These considerations seem to Her Majesty's Government to render it absolutely necessary that the defences of Quebec should be materially strengthened and without delay. They intend, therefore, on their own part to include in the Estimates of the present year a vote for improving the defences of Quebec.

The proposed defences at Montreal are so important to the general safety of the province, and to the maintenance of the communication between the Districts West of Montreal, and the naval and military power of the Mother country, that Her Majesty's Government trust that they may look with confidence to the Government of Canada for the immediate construction of these Works.

Her majesty's Government will be prepared to provide the armaments for the Works at Montreal as well as for those at Quebec.[23]

While the British cabinet ministers that met with the Canadian delegation later in 1865 confirmed that the Imperial exchequer would fund the construction of new forts at Quebec City according to Jervois's plan, they also stressed that, in the spirit of shared defence responsibilities, the Canadian government would have to pay to build

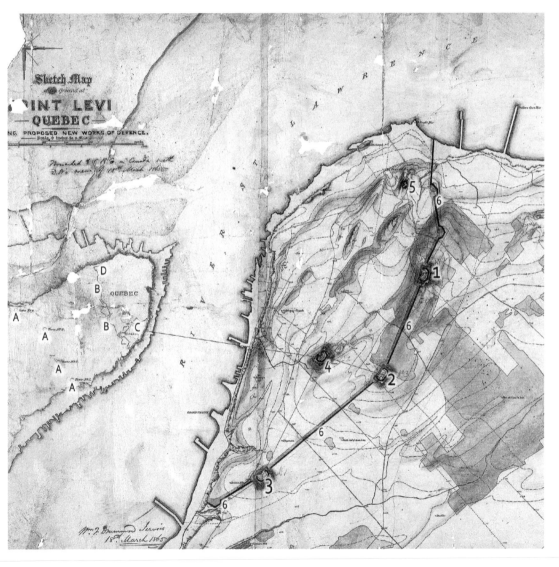

William F. Drummond Jervois, R.E., 1865.
Sketch map of the ground at Point Levi Quebec showing proposed new works of defence. (detail)
[Courtesy of Library and Archives Canada, NMC 11271, H1/340/Levis/1865.]

[Annotations by Marc Seguin]

1 Fort No.1
2 Fort No.2
3 Fort No.3
4 Fort No.4 (not built)
5 Artillery battery (not built)
6 Entrenchments (not built)

A Martello Towers
B City walls
C Quebec Citadel
D Artillery park and barracks

the fortifications at Montreal, Kingston, Toronto and Hamilton as recommended by Jervois. Not wanting to complicate the ongoing Confederation talks with the other North American colonies, the British cabinet ministers had agreed to take the proposal to the Imperial parliament after the Confederation question had been decided.

Jervois's plan included the construction of five separate fortifications on the heights of Lévis across the St. Lawrence River from Quebec City. There would be a fortified gun battery to cover the eastern river approaches to the city. Beyond the battery would be a line of three forts; numbered one, two, and three, stretching across the landward side of Pointe Lévis. These would be connected by entrenchments forming an arc up to a mile back from the river to protect the city's southern and western approaches. A fourth fort, centrally located behind the others, would cover the rear and provide defensive fire in the event that any of the other forts or the gun battery were overrun by an enemy force.

By the time construction was begun later in 1865, the gun battery and the fourth fort had been dropped from the plan due to budgetary constraints. The officer commanding the Royal Engineers at Quebec, Colonel R.G. Hamilton, decided that only Fort No.1 would be built entirely by the military while the construction of the other two forts would be given over to a private contractor under the supervision of the Royal Engineers.

A new wharf on the St. Lawrence River was built at Pointe Lévis to land workmen and construction materials from Quebec City, and roads to the construction sites were laid. Adjacent to the site of Fort No.1, a collection of barrack buildings and offices for the Royal Engineers was built and the surrounding land was cleared for a bivouac area where the troops working on the construction project could pitch their bell tents.[24]

OPPOSITE — William Ogle Carlile, c.1870.
The Building of No.1 Fort to Defend Quebec. (composite)
[From *Recollections of Canada*, 1873.]
Carlile's whimsical side is shown here in this group of five of his ten cartoons representing the construction Fort No.1 at Pointe Lévis. Lieutenant-Colonel Martindale, in his tongue-in-cheek manner, writes in *Recollections of Canada*,

> "Carlile, a man of strict veracity, asserts that he took the whole of these sketches on the spot. Their accuracy must therefore be considered as past doubt."　　[*Recollections of Canada*, p.24.]

• *C.R.E. Selects Site for Fort No.1* — Colonel Hamilton, the commanding officer of the Royal Engineers at Quebec City decides to have the British Army, instead of civilian contractors, build Fort No.1.

• *These are the chosen few who are to build the Fort* — The soldiers of the garrison were tasked with the construction work.

• *R.E. taking a birds-eye view of Country* — This cartoon is lampooning the Royal Engineer officers who surveyed the site of the new fort.

• *Masonic operations* — Construction of fort No.1 is under way by the fall of 1865.

• *The unbounded bounding delight of* [Colonel Hamilton] *R.E., at the Fort being finished* — Even after the last Imperial garrison departed, the Royal Engineers still had work to complete on Fort No.1. It was finally finished and transferred to the Canadian Militia Department in 1872.

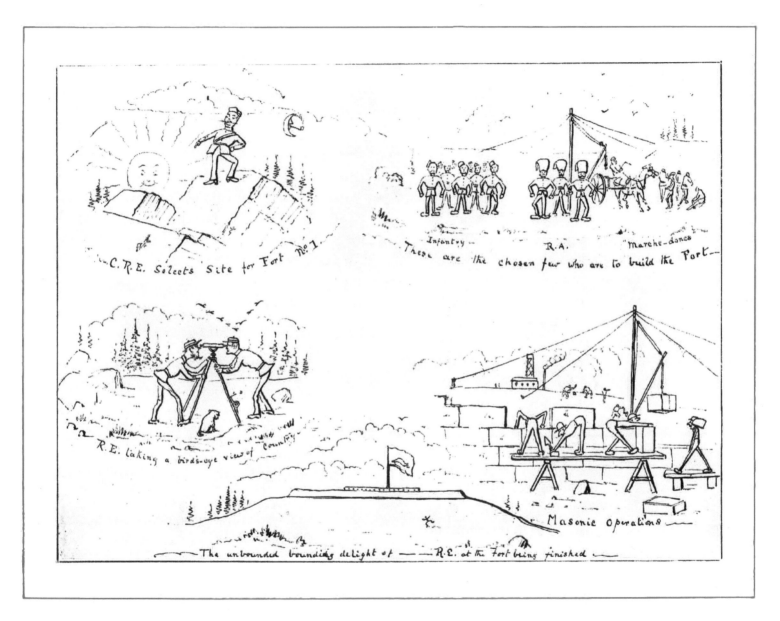

THE BUILDING OF Nº1 FORT TO DEFEND QUEBEC.

The design of the Lévis forts was such that they were essentially embedded in the surrounding landscape. Massive excavations were made, inside of which masonry walls and vaulted casemates for barracks, storerooms and gunpowder magazines were built and covered in a thick layer of earth for protection from hostile artillery fire. The walls were up to sixteen feet high and set back from the edge of the excavation to form a deep, dry ditch all around each fort. Their low profile meant that the forts were virtually invisible from ground-level; presenting less of a target for enemy artillery. Each of the forts was located about one mile from an adjacent fort and each was designed to mount three large 64-pounder rifled muzzle-loading cannons on the ramparts. These guns had a range of more than two miles. This allowed each fort to provide covering fire for at least one other fort. Smaller, short-range carronades inside the forts defended the dry ditches.

The contractor had the bulk of the work on Fort No.2 and Fort No.3 completed by 1869, leaving the Royal Engineers to add the gates and drawbridges. At Fort No.1, progress was much slower. Here, British Army regulars from the 30th Regiment, the 60th Kings Royal Rifle Corps and the 69th Regiment working for extra pay provided the bulk of the labour force. Army regulations limited the soldiers' labour to a five-day work week and, since they were living in tents while working on the fort, the soldiers were allowed to work only four months of the year. This compared to a six-day work week for six months of the year

for the civilian contractors working on the other two forts. By the time the three Lévis forts were handed over to the Canadian government in 1872, still without armaments, they had cost the Imperial Exchequer more than £175,000.[25]

In the end, the improvements to the Great Lakes naval base at Kingston were never made, and the fortifications at Montreal, Toronto and Hamilton, all of which the Canadian government had repeatedly promised to build as their share of the defence of Canada, were never constructed.

OPPOSITE — William Ogle Carlile, 1871.
No.2 Fort, Levis.
[*Canadian Illustrated News*, 25 November 1871.]

"In this issue we give a sketch of the second of the three forts erected in South Quebec, or Point Levis, on the side of the St. Lawrence opposite the ancient capital. They command the whole of the country around Quebec, the approach to the city by the St. Lawrence, and the upper end of the Island of Orleans. They are built on improved modern principles; no enemy can breach the escarp, nor exist one minute in the ditch, from the mode of defence devised. And were it possible that he could get into the forts, he would be utterly unable to hold them, for the Citadel of Quebec would straightaway pound him out with its artillery. The views are much the same of all the forts....

"Of course we do not wish to 'show our hand' to any lurking enemy, and, therefore, conclude by saying that these Point Levis fortifications have unquestionably confirmed Quebec's proud claim to being indeed 'the Gibraltar of the North'."

[*Canadian Illustrated News*, 25 November 1871, p.339.]

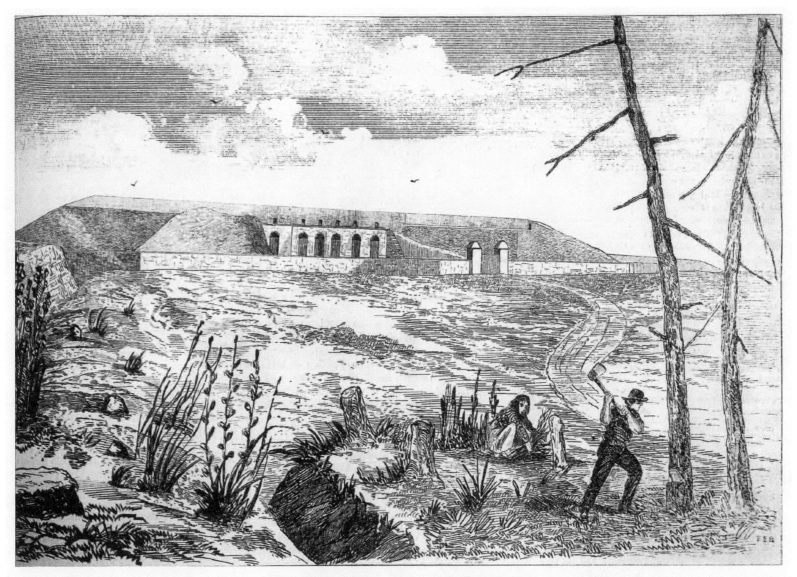

NO. 2 FORT, LEVIS. FROM A SKETCH BY W.O.C.

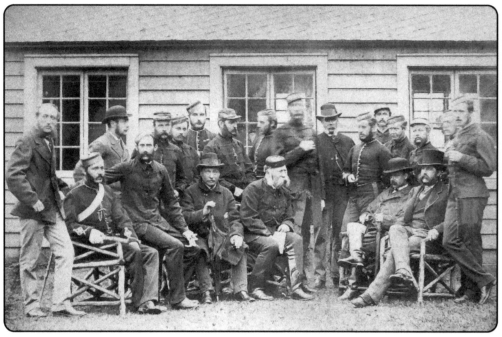

Photographer unknown, 1870
R.A.(Royal Artillery) **and R.E.**(Royal Engineers)**, Quebec.**
[D.T. Irwin collection. Courtesy of the Irwin family of Ontario, Canada]

A group of officers of the Royal Regiment of Artillery and the Corps of Royal Engineers at Quebec City.
Seated (L to R): Lt. W.O. Carlile RA, Lt. A.M. Brown RA, Col. F.C. Hassard RE, Col. G.L. Chandler RA, Dr. D. Park RA, Maj. R.O. Farmer RA.
Standing (L to R): ? Appleby, unnamed, Lt. D.J.G. Stanley RA, Lt. D. O'Brien RE, 2nd-Capt. H.C. Farrel RA, Lt. G. Harris RE, Lt. A.W. White RA, unnamed, unnamed, Lt. D.D.T. O'Callaghan RA, Lt. H.S. Sitwell RE, Lt. Price RE, Lt. H. Robinson RE, ? Lake, Lt. D.T. Irwin RA.

Chapter 6

The Last Imperial Garrison

After more than a year of negotiating with the Imperial authorities, trying to convince them not to withdraw all of the British troops defending Canada, the prime minster, Sir John A. Macdonald, in April 1870, expressed his frustration with the British government and its insistence on total troop withdrawal. In a private letter to the Earl of Carnarvon, who had been the colonial secretary under Britain's previous Conservative government leading up to Canadian Confederation, Macdonald wrote:

> We greatly distrust the men at the helm in England who cannot, I fear, be considered as appreciating the importance of maintaining the Empire as it is, intact....
>
> The withdrawal of the troops from Canada is, I think with you, a most unwise and short-sighted proceeding....
>
> They choose to withdraw every soldier from us, and we are left to be the unaided victims of Irish discontent [the Fenians] and American hostility [over the "*Alabama* Claims"], caused entirely by our being a portion of the Empire. We must, however, bear it as best we may, and we intend, with God's blessing, to keep our country, if we can, for the Queen against all comers.[1]

Macdonald's remarks were not unfounded. Rumours of further Fenian raids swirled throughout the country until, only a few weeks later, a body of armed Fenians crossed the international boundary south of Montreal. Fortunately, most of the Fenians' supply of weapons had been intercepted at the border by the U.S. Army, and those Fenians who did manage to cross into the Province of Quebec were repulsed at Eccles Hill and Trout River by a combined force of British regulars and Canadian Militia.[2]

At the same time, however, to add to the young country's troubles, the Canadian government was confronted with an armed uprising in its newly-acquired western territories. After Canada had purchased the rights to the vast tract of the North West Territories from the Hudson's Bay Company in 1869, disgruntled settlers in the Red River settlement, organized by the Metis leader Louis Riel, staged a rebellion and established a provisional government.

To assert Canada's authority over the region, the Canadian parliament authorized the dispatch of a military expedition to Fort Garry on the Red River. This combined force of British regulars and Canadian Militia included a portion of the garrison of Quebec City — seven companies of the 60th Kings Royal Rifles, a detachment of the Royal Artillery with four Armstrong guns and nineteen Royal Engineers — along with two battalions of militia volunteers — one from Ontario and the other from Quebec — all under the command of Colonel Garnet Wolseley of the British Army. William Ogle Carlile's sketch of a portion of the expedition departing from Quebec City for the Red River (opposite) was published in the *Canadian Illustrated News*.

The expedition embarked in May 1870, on an arduous journey of many weeks, first by train to Collingwood on Lake Huron, then by steamboat to the head of Lake Superior. Travel further west from there was over newly cleared roads and by boat along waterways with numerous portages. When they finally arrived at Fort Garry in July, they found that the rebels had fled.[3] In the meantime, Parliament had passed the Manitoba Act to admit the Red River settlement to the Canadian Confederation as the Province of Manitoba. The expedition returned to the east with a detachment of Canadian volunteers left behind to maintain law and order and to defend the new province against rumoured Fenian raids.

In June 1870, one final attempt had been made to persuade the British government to leave, at the very least, a small body of regular troops at Quebec City as a show of Imperial strength. The Postmaster-General, Alexander Campbell, was sent to London to plead Canada's case. On his return in September 1870, Campbell dejectedly reported on his discussions with Lord Kimberley, the Liberal government's new colonial secretary:

> I submitted to Lord Kimberley that when the Confederation of the several Provinces of British North America was suggested, it was agreed on all sides that it was a matter of both Imperial and Colonial Policy, that Canada felt assured in carrying out the scheme that it would have the advantage of the moral and material support of the Empire.... There was a growing feeling in Canada of distrust in the disposition of the Imperial Government to give us that support to which we thought ourselves entitled....

OPPOSITE — William Ogle Carlile, 1870.
Red River Expedition — Engineers Leaving Camp at Levis.
[*Canadian Illustrated News*, 4 June 1870.]

"A body of Royal Engineers, nineteen strong, have accompanied the Red River expedition, for the purpose of making plans of the territory and engaging in other operations connected with their particular branch of the service. The men are under the command of Lieut. Heneage, R.E., who has been engaged for some time past in putting them through a course of preparatory training....

"We commence our series of illustrations relating to the Red River expedition with a sketch, by our special artist in Quebec, of the departure of this corps...."

[*Canadian Illustrated News*, 4 June 1870, p. 482.]

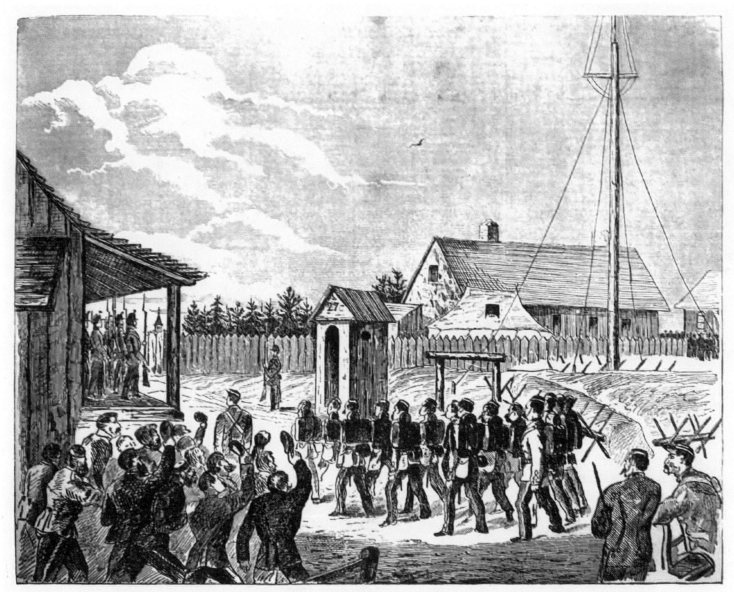

RED RIVER EXPEDITION — ENGINEERS LEAVING CAMP AT LEVIS. FROM A SKETCH BY W.O.C., LT. R.A.

Lord Kimberley said that his attention had been called to the feeling of distrust to which I had referred, but that he thought nothing had been done by the British Government to afford any grounds for it: there was no desire to separate Canada from the Empire.... but so long as she chose to remain connected with the Empire, so long under all circumstances of foreign aggression was the Empire bound to maintain the union, and would do so, but in internal affairs it was the duty of Canada to protect herself.

I said that we had for many years undertaken the maintenance of the internal peace of the country, but that we did not consider the Fenian invasion an internal trouble, but one proceeding from Imperial causes, from which the Imperial government should protect us, or against the expense of which they should indemnify us. I urged that it would re-assure the public feeling in Canada very much if the garrison at Quebec were to be maintained: we did not ask this on account of the number of men which might be placed there, but because their presence would be to us a symbol of the sovereignty of the Empire. Quebec was an Imperial fortress, and the maintenance of the garrison of Her majesty's troops there would be looked upon as indicating the determination in England to maintain the existing relations, and would have the most useful effect on public feeling in Canada....

Lord Kimberley said that the matter had been repeatedly and very fully considered, and that the decision that had been arrived at was not likely, he thought, to be departed from....[4]

In light of the recent raids by the Fenian Brotherhood and the troubles in Manitoba, the War Office did postpone the withdrawal from Quebec City of one battalion of infantry along with a battery of artillery and a company of engineers until the end of 1871. At the same time, however, the War Office announced that the Royal Canadian Rifle Regiment, a regular army regiment which had been raised initially in 1840, strictly for service in British North America, would be disbanded. The Canadian government had shown no interest in paying for the regiment, so this would leave Canada with no defence force except for the under-trained volunteer militia and the paper force of the Reserve Militia.

The British Army's Commander-in-Chief in Canada, Lieutenant-General Lindsay, estimated that Canada, at the very least, would have to provide permanent garrisons at several locations including Montreal, Quebec City and Kingston.[5] These garrisons, along with detachments based at military stations planned for Ile aux Noix, Toronto and Hamilton, would total no fewer than seven hundred trained men plus the required number of officers and support personnel. Lindsay recommended to Canada's Minister of Militia and Defence that a regular regiment be raised from among those British soldiers currently serving in Canada who desired to stay in the country as part of the new Canadian Army. This recommendation was rejected by the Canadian Government which continued to refuse to consider recruiting a permanent force. That, they steadfastly believed, was an Imperial responsibility.

By a happy coincidence, the Treaty of Washington was signed in May, 1871, and it was quickly ratified by both the United States Congress and the Parliament of Great Britain.[6] While the treaty did not address any of Canada's claims against the United States for compensation for the Fenian raids, it did satisfy the Americans by sending the troublesome "*Alabama* Claims" to international arbitration. At the same time, Canada's adjutant-general of the militia, Colonel Robertson-Ross, expressed confidence that the Canadian volunteers could be called up quickly, "to crush any attempt at Fenian invasion" along the United States border with Ontario and Quebec.[7] In this atmosphere of relative calm and security, the War Office decided that the last garrison defending Canada would be withdrawn from Quebec City in November.

By that time, the Canadian Government had already conceded defeat in its battle with the Imperial authorities over keeping a British garrison in the country for the defence of Canada. In April, 1871, just seven months before the final troop withdrawal, during the budget debate in the Canadian Parliament, the government made the necessary financial arrangements for the maintenance of the artillery and military stores that were to be handed over to the Canadian Militia by the departing British regulars. The appropriation included funds for a permanent militia headquarters staff headed by Adjutant-General Robertson Ross, as well as a permanent artillery staff at Quebec and Kingston where gunnery schools would be established for training militia gunners.

During the debates, the Minister of Militia and Defence , George-Étienne Cartier, assured Parliament that the newly authorized garrison artillery batteries would not constitute a standing army burdening the Canadian treasury with unnecessary military expenses. This, he firmly believed, should remain the responsibility of the Imperial government:

> With regard to maintaining a permanent force or regiment in this country, the Government had no such intention. (Hear, hear.) Since England had thought proper to withdraw her army, it was not incumbent on the Dominion Government to organize a permanent regiment. (Hear, hear.)....
>
> The Government intended to have garrison batteries composed of a hundred men each; a portion of them was to be stationed at Toronto, a full battery at Kingston, and half battery at St. Helen's Island, Montreal.... but it was not the intention of the Government to make a permanent service of these batteries. It was their intention to call periodically on those composing the active militia in each district and give them a chance of serving in rotation either three or six months; but the Government had not established a permanent force. (Hear, hear.)[8]

Ever the politician, Cartier put a different spin on the situation when addressing the Canadian Militia at their first training camp at Niagara just two months later, by emphasizing the need for Canada to have its own "sufficient military force":

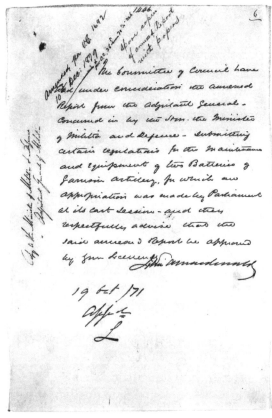

Order-In-Council 1871-1446, Oct. 19, 1871.
[Courtesy of Library and Archives Canada, RG2, Privy Council Office, Series A-1-a volume 291, Reel C-3298.]

By this Order-in-Council, signed by Prime Minister Sir John A. Macdonald and initialed by Governor-General John Young Baron Lisgar, the first permanent elements of the Canadian Army were created. The annex referred to became Militia General Order 24 issued to the Canadian Militia the following day (see Appendix B).

A country can never think of becoming great if it is not in a state to resist those enemies who threaten its existence. The Imperial Government is blamed for having withdrawn the troops from Canada with so much precipitation. But, however blamable this act may be in the eyes of a great many, it should not prevent the parliament and people of Canada from organising and maintaining, according to the means and the resources of the country, a sufficient military force to make us respected.[9]

On the same occasion, the minister commented to an American general who had been invited to view the militia exercises, "That, whilst desiring to live on a footing of friendship with the United States, prudence counselled us not to live disarmed, that we furbished our arms hoping never to have to use them, and that our idea was simply to defend ourselves, and never to make conquests."[10]

The "sufficient military force" maintained "simply to defend ourselves", would be composed of the citizen-soldiers of the volunteer militia along with a new, though rather small, full-time permanent force. This force was finally authorized just twenty-three days before the last British troops defending Canada were scheduled to depart. An Order-in-Council of October 19, 1871, approved Militia General Order 24 which established the first permanent body of Canadian troops; the first tentative step on the long path to the creation of Canada's own professional standing army.[11]

Two Dominion Artillery batteries were authorized with a total strength of 360 officers and men. "A" Battery was established at Kingston with a detachment at Toronto, and "B" Battery was established at Quebec City with detachments at Lévis and Montreal. These batteries would be responsible for the ordnance in the forts, and they would also serve as gunnery schools for the militia artillery. The new permanent batteries included seventy experienced Royal Artillery gunners who had volunteered to remain in Canada and serve in the Canadian Militia.[12] Around this core group were officers and men temporarily detached from their local volunteer militia artillery batteries (see page 89) who would serve for up to twelve months at a time while attending the new gunnery schools and performing garrison duty.

Lieutenant George Arthur French, an officer in the Royal Artillery's 3rd Brigade who had been acting as the Inspector of Artillery and Warlike Stores for Canada, was given command of "A" Battery. He was also appointed commandant of the Kingston gunnery school with the rank of lieutenant-colonel in the Canadian Militia. French had been an upper-classman at the Royal Military Academy at the same time that William Carlile was studying there. French had arrived in Canada with the 10th Brigade in 1862 during the "*Trent*" Affair". When his brigade was posted to Malta in 1867, he had arranged a transfer to the 3rd Brigade so that he and his Canadian wife, Janet Innes, could remain in Canada. French commanded "A" Battery for two years before being appointed the first

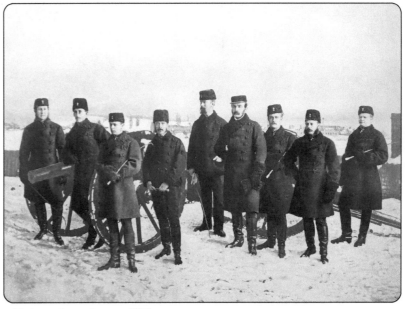

Photographer unknown. 1872.
Tete du Pont Barracks, Kingston.
[D.T. Irwin collection. Courtesy of the Irwin family of Ontario, Canada.]

This photograph shows the officers of "A" Battery of Canada's newly formed garrison artillery and gunnery school at Kingston.
L to R: Dr. O.S. Strange ("A" Battery, assistant-surgeon), Capt. J.G. Holmes (St. Catharines Garrison Battery), Lt. P.R. Ricardo (Durham Field Battery), Maj. D.T. Irwin ("A" Battery second-in-command), Capt. J. Egleson (Ottawa Garrison Artillery), Lt.-Col. G.A. French ("A" Battery commander), Lt. J. Cotton (Ottawa Garrison Artillery), Capt. W.H. Cotton (Ottawa Garrison Artillery), Lt. F. Wilson (Kingston Field Battery).

OPPOSITE — William Ogle Carlile, 1870.
Volunteer Artillery Practice on the Island of Orleans.
[*Canadian Illustrated News*, 29 October 1870.]

Canada's first permanent force, established in October 1871, consisted of two batteries of garrison artillery, "A" Battery and gunnery school at Kingston, and "B" Battery and gunnery school at Quebec City, with a total authorized strength of 360 officers and men. Seventy gunners of the Royal Artillery volunteered to stay in Canada and serve with these newly formed batteries of the Dominion Artillery. The other 290 gunners would be seconded from the volunteer artillery batteries of the Canadian Militia for temporary duty with the permanent force for up to twelve months at a time.

"We present to our readers a view taken on the 1st of September last at the camp of the 'Quebec Garrison Artillery', Volunteer Militia of Canada, which we think will be of interest. The camp was situated on the Isle of Orleans, a few miles from Quebec, one of the most beautiful spots around the city....

"The 'Quebec Garrison Artillery' consists of four batteries of fifty-five men each, under the command of Lieut.-Colonel Bowen, and is composed of a fine hardy set of men, partly mechanics and partly stevedores, and others connected with the shipping."
[*Canadian Illustrated News*, 29 Oct. 1870, p.283.]

VOLUNTEER ARTILLERY PRACTICE ON THE ISLAND OF ORLEANS. FROM A SKETCH BY W.O.C.

commanding officer of the North West Mounted Police in 1873. His second-in-command, Delroy Irwin, another RMA Woolwich classmate of William Carlile's, then took command of the battery and the Kingston gunnery school.[13]

Captain Thomas Bland Strange was given command of "B" Battery at Quebec City, with the rank of lieutenant-colonel in the Canadian Militia. First commissioned as an officer in the Royal Artillery in 1851, he had served with distinction during the Indian Mutiny (1857-58). Before arriving to take command of the new Canadian battery and gunnery school at Quebec City, Strange had been an instructor at the Royal Artillery's Shoeburyness gunnery school in England.[14]

Meanwhile, in the busy months leading up to the final departure of the British Army, there were a number of command changes in No. 5 Battery. Lieutenant Carlile had been appointed second-in-command of the battery in September 1870, and then given temporary command of the entire battery in June 1871.[15] During his tenure as battery commander, preparations for the withdrawal of the last Imperial garrison continued at a hectic pace. Working with the transport and supply officer at Quebec City, Lieutenant-Colonel Martindale of the British Army's Control Department, Carlile and his men were kept busy disposing of surplus ordnance and organising the artillery stores that were to be retained by the departing British forces. Old Congreve rockets and outdated artillery shells were destroyed, obsolete cannons were rendered unserviceable, and artillery and military stores that the British Army did not want to leave behind were gathered at the Queen's Wharf awaiting shipment back to Britain.

In spite of the extra work due to his new command, William still found time to record several scenes of his final months in Canada. This included one cartoon (opposite), "Evacuation of Quebec", which, perhaps, expresses some of the frustration he felt undertaking the frenetic preparations to leave Quebec City.

OPPOSITE — William Ogle Carlile, c.1871.
Evacuation of Quebec.
[From *Recollections of Canada*, 1873.]

"I have spoken to Carlile in vain about his sketch. He *will* have that it is exactly what he saw, and that any one who was at Quebec at the time will recognise its truth....

"He is supposed to be the individual at the extreme corner of the sketch... and it is said that the next figure is the Controller [Lieutenant-Colonel Martindale]....

"I have pointed out that the way in which the most valuable 'military stores', foolscap, red-tape, ledgers, correspondence, and such like, are scattered on the ground, may convey a very wrong impression, and worse moral....

"In his more reasonable moments Carlile says in a soothing tone that this sketch is an allegory, and meant to commemorate the pressure of work occasioned by the evacuation of Quebec, and the successful arrangements made to overcome it....

[B.H. Martindale, *Recollections of Canada*, 1873, p. 49.]

EVACUATION OF QUEBEC.

OPPOSITE — William Ogle Carlile, 1870.
Breaking Trunnions Off Old Guns on St. Helen's Island, Montreal.
[*Canadian Illustrated News,* 12 November 1870.]

"In addition to the destruction of [300,000] shells, there were some four or five hundred old guns rendered unserviceable by smashing off the trunnions with a 68-pounder shot. This is effected by a single blow. The guns on the Island were mostly 24-pounders, a calibre which modern progress in the art of destruction has rendered almost obsolete. When new, they cost £100 sterling; but they have been sold at an average of about $50 [£10 sterling] each to an enterprising American who received them as fast as they were rendered unserviceable, and doubtless took the first opportunity of turning them into stove metal, or some other equally practical purpose. It may be noted that a large quantity of the military stores, including ordnance, were entirely antiquated, and would have been utterly unfit for service at the present day. What was really good was either transferred to England, lodged in Quebec for Imperial account, or handed over to Canada. The useless trash only has reverted to other purposes for which it may still be made serviceable."

[*Canadian Illustrated News,* 12 November 1870, p.311.]

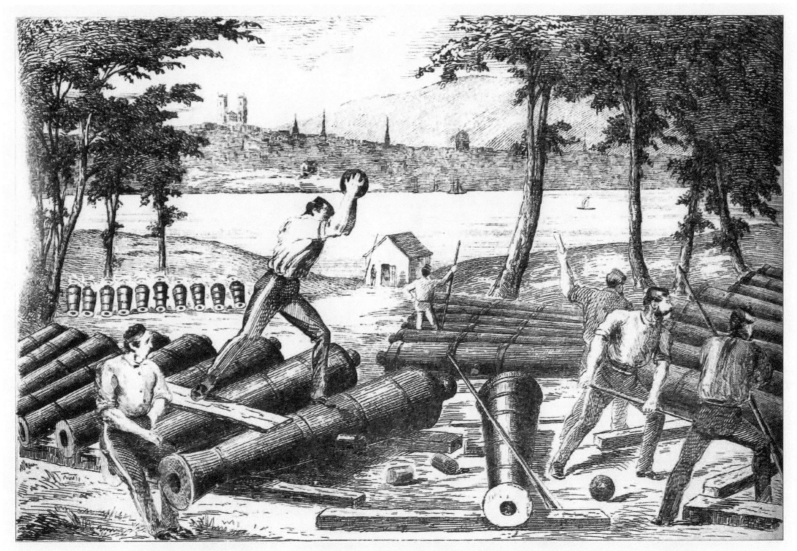

BREAKING TRUNNIONS OFF OLD GUNS ON ST. HELEN'S ISLAND, MONTREAL. FROM A SKETCH BY W.O.C.

OPPOSITE — William Ogle Carlile, 1871.

Drawing Old Cannon to the Queen's Wharf Through the Lower Town, Quebec.

[*Canadian Illustrated News*, 18 November 1871.] 1 of 2.

"Little by little the last remnants of the Imperial military occupation of Canada are disappearing or being concentrated into very small space. In our present issue we give two illustrations from sketches by our special artist, one of them shewing a gun in a sling waggon being driven through Lower Town, Quebec, to the wharf for shipment to Montreal. The guns not required by the Dominion Government were sold to the firm of Messrs. Ross & Co., of Quebec. Before the guns were delivered over to their purchasers, the trunnions were broken off in the manner shewn last year [see page 93]....

"The citizens of Quebec naturally feel somewhat despondent at the transactions depicted in our illustrations, as they deem them indicative of the departure of the ancient glory of their city. But they have a full supply of far more serviceable pieces of ordnance, either mounted or ready to be mounted. Whereas the stock which has recently been passed through their streets was really nothing but rubbish...."

[*Canadian Illustrated News*, 18 November 1871, p.323.]

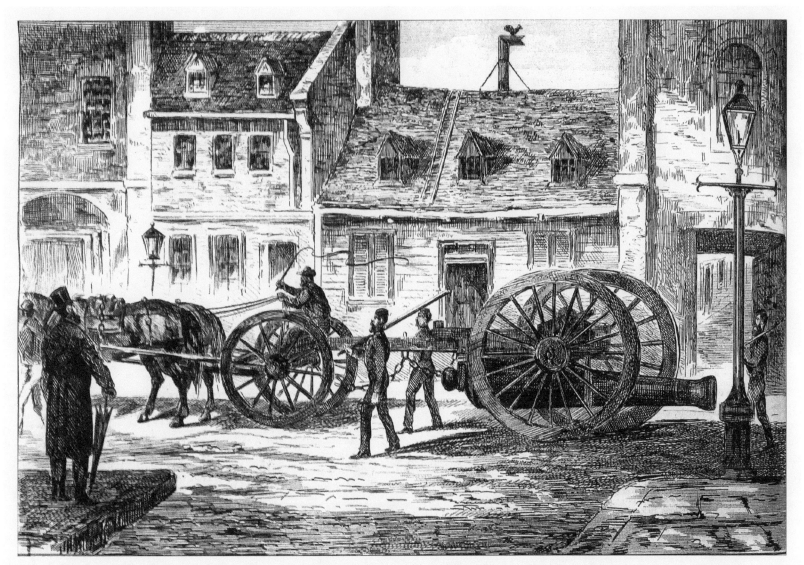

DRAWING OLD CANNON TO THE QUEEN'S WHARF THROUGH THE LOWER TOWN, QUEBEC. FROM A SKETCH BY W.O.C.

OPPOSITE — William Ogle Carlile, 1871.
The Queen's Wharf, Quebec.
[*Canadian Illustrated News,* 18 November 1871.] 2 of 2.

"The sketch shows the Queen's wharf, Quebec, covered with military stores of all descriptions, including heavy guns, field-pieces, shot and shell, coal, boxes, waggons, wheel and hand-barrows, &c. &c. Some of them were brought to the wharf for shipment to England; others of them for distribution in Canada. The guns are all either obsolete patterns or are beyond the requirements of the Canadian Government. The Armstrong guns in the foreground of the picture are 64 pounders; their place being supplied with the same gun but of 110 lbs calibre. Three of the new ones were mounted some weeks ago."

[*Canadian Illustrated News,* 18 November 1871, p.323.]

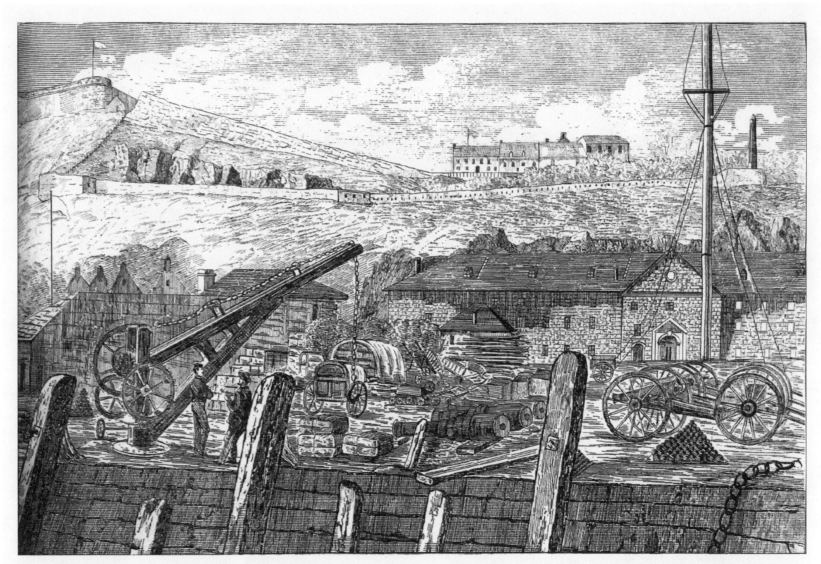

THE QUEEN'S WHARF, QUEBEC, SHOWING THE CONDEMNED STORES AND AMMUNITION ACCUMULATED FOR SALE OR SHIPMENT. FROM A SKETCH BY W.O.C.

In October 1871, the troopship *HMS Orontes* was dispatched from Portsmouth, England, to evacuate the last Imperial garrison from Quebec City. When news reached the city by telegraph that *Orontes* had reached Halifax and would soon be on her way up the St. Lawrence River, the prominent residents of Quebec threw a ball for the departing regiments.

On November 9, the troopship arrived at Quebec City, and two days later, on Saturday, November 11, 1871, the last British troops defending Canada marched out of their barracks and boarded the ship. The newspaper, the *Quebec Daily Mercury* gave a detailed report of the event:

DEPARTURE OF THE BRITISH TROOPS

The Imperial troops hitherto forming the garrison of Quebec, consisting of one battery of the 3rd Brigade Royal Artillery, one company of the Royal Engineers, and the 1st Battalion of the 60th Royal Rifles, marched down in the above order to the St. Andrew's wharf, at half-past two o'clock this afternoon, to embark in H.M. steam troopship *Orontes*, for conveyance to Halifax....

The band of the 60th, during the march from the Citadel to the wharf, played the airs of "Good Bye, Sweetheart, Good Bye" and "Auld Lang Syne." A large number of citizens were present at the embarkation to bid farewell to the departing troops.... Several of the Control Staff will remain till the 25th instant, when the last mail steamer will leave, in order to complete the transfer

arrangements between the Imperial and Dominion authorities. A guard furnished from the detachments remaining will occupy the Citadel till relieved by the Dominion Militia.[16]

Curiously enough, the local Quebec volunteers did not put in an appearance as noted by the *Daily Mercury's* correspondent:

We regretted to notice the absence of our Volunteer Bands at the embarkation of the troops today. Surely those of the 8th and 9th [regiments of Quebec militia] might have been present to enliven the occurrence with a few parting strains, and show that they had some martial spirit in them. Apart from the importance of the occasion from a

OPPOSITE — William Ogle Carlile, 1871.
Ball Given to the 60th Regiment by the Citizens of Quebec.
[*Canadian Illustrated News*, 25 November 1871.]

"In the Music Hall last night took place the farewell ball given the officers of the garrison by the citizens of Quebec. The affair was a decided success....

"In the centre of the green curtain was a large medallion with the inscription:

WELCOME.

Success to our Friends in all Parts of the World.

FAREWELL.

"The attendance was not quite so large as had been expected, but... the beauty, wit, and talent of the city was fully represented by the assembly."
[*Canadian Illustrated News*, 25 November 1871, p.339.]

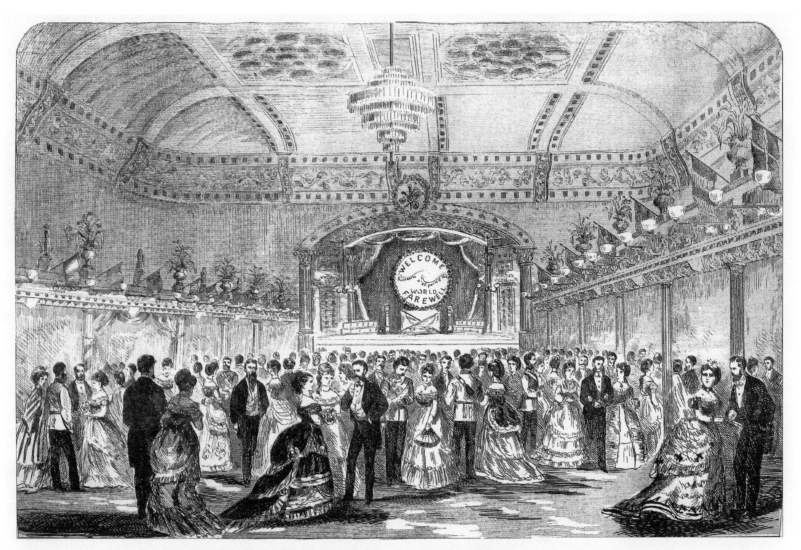

BALL GIVEN TO THE 60TH REGIMENT BY THE CITIZENS OF QUEBEC. FROM A SKETCH BY W.O.C.

patriotic point of view, military etiquette would seem to have demanded some such marks of sympathy with the gallant troops who are leaving our shores.[17]

This may simply have been an oversight by the local militia commanders, or it may have been a deliberate refusal on the part of the Canadian government to acknowledge what they saw as the abandonment of Canada by the British Army under orders from the Imperial government.

An editorial in the newspaper went on to lament the transition that was taking place:

THE MILITARY EVACUATION OF QUEBEC

Today is one which should be memorable in the annals of our city. England has withdrawn her garrison, from hence forward Canada is to provide her own defence. The evacuation of the Province is perfect and complete, and our citizens must provide for their own internal tranquility, and the Dominion must (should the United States Republic fail in preserving the peace of its frontier) protect its frontier by its own power and resources.

No doubt there are few of our citizens but regret the departure of the kindly, good natured and well disciplined troops of England, the most modest and forbearing of all soldiers towards the citizen and the most formidable of all in the presence of the enemy. No doubt the gallant and genial British officers will be regretted by a society to which most of them were an ornament, as they would be in any society, nevertheless the duty of the city, the

Province and the Dominion is one. It is to accept facts, to reconcile Colonial to Imperial interests and the circumstances of the day. There can be no doubt that the withdrawal of the troops from Canada is a portion of a well matured and deliberately adopted policy, and to that policy Canada must bow....[18]

Quebec City's principal French language newspaper, *Le Canadien*, presented a somewhat different perspective:

THE LAST ENGLISH REGIMENT.
[translation]
Yesterday, the *Orontes* left Quebec carrying with her the last English regiment.
The old citadel of Quebec is now widowed of British soldiers and contains no more than some women and a few invalids.

OPPOSITE — William Ogle Carlile, 1871.
The Royal Artillery Leaving Their Barracks, Quebec.
[*Canadian Illustrated News*, 2 December 1871.]

"In the present issue we give... a view of the Royal Artillery as they left the Palace Gate Barracks on their homeward trip by H.M.S. 'Orontes'.... The battery was under command of Captain Cardew, the other officers being Captain Graham and Lieuts. Crookenden and Carlile."
[*Canadian Illustrated News*, 2 December 1871, p. 354.]

This same image appeared in *L'Opinion Publique Journal Illustré*, two days earlier, but it carried a different caption: "Les Ingénieurs Royaux Quittant Leurs Casernes" [trans: The Royal Engineers Leaving Their Barracks.]

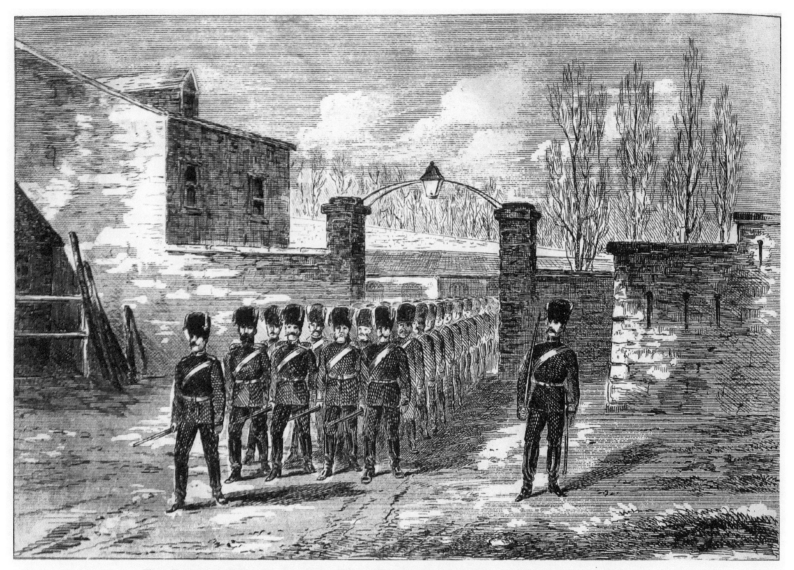

THE ROYAL ARTILLERY LEAVING THEIR BARRACKS, QUEBEC. FROM A SKETCH BY W.O.C.

Will they ever come back to defend the old English flag, we think not! This departure is one of the most remarkable events since the conquest.

French soldiers were chased out by the English armies after glorious battles, but the English soldiers leave without fighting before peaceful but no less powerful American armies.

A sign of the times![19]

The journal of the Canadian Militia, *The Volunteer Review and Military and Naval Gazette,* proffered these remarks:

On Saturday the 11th November 1871, seemed one of the most remarkable events of Canadian history, namely the evacuation by the British troops of the old fortress of Quebec which they had occupied for over 112 years. About two o'clock that day the garrison, consisting of one company of the Royal Engineers, one battery of the 3rd Brigade Royal Artillery and the 1st Battalion of the 60th Royal Rifles, marched down to the St. Andrew's wharf headed by the band of the 60th, playing the usual airs which greet so sorrowfully the female ear on like occasions, and embarked on the steam transport *Orontes* which sailed for Halifax the following day.

By some strange oversight, want of good taste on the part of the civil authorities, no public demonstration marked the occurrence of so signal an event, not even the usual address on behalf of the citizens, testifying their appreciation of the good conduct of the corps during their stay in the garrison, but a great number of friends were on the wharf to wish them God-speed.

By a singular coincidence the very same regiment (the 60th or Royal Americans) which was the first to enter Quebec on its surrender in 1759 was the last to leave it 112 years later.

The citadel is now occupied by B Battery of the Dominion Artillery who are uniformed so like the Royal Artillery and look so neat and soldier-like that it seems hard to believe that any change has been made. May we ever imitate the qualities, as we do the uniform, of old Britain's noble army, for if we do we have nothing to fear for the future....[20]

OPPOSITE — William Ogle Carlile, 1871.
Departure of the Troops — The *Orontes* Leaving Quebec. Point Levis in the Distance.
[*Canadian Illustrated News*, 9 December 1871.]

"We give an illustration of the departure of the last installment of troops from Quebec for Halifax, which took place on the 11th ult. The view shows the steamship 'Orontes' leaving Quebec, with Point Levis in the distance. Last week we gave a couple of sketches showing the 60th [see page 6] and the Royal Artillery [see page 101] on their way to go on board the 'Orontes', and now we shall conclude these military views relating to the removal of the Imperial troops from the ancient capital with an illustration of the scene."
[*Canadian Illustrated News*, 9 December 1871, p. 379.]

DEPARTURE OF THE TROOPS — THE *ORONTES* LEAVING QUEBEC. POINT LEVIS IN THE DISTANCE. FROM A SKETCH BY W.O.C.

Just prior to the regiment's departure, one soldier in the 60th Regiment (King's Royal Rifle Corps), penned a poem that was printed in the *Quebec Morning Chronicle*:

THE 60TH FAREWELL TO CANADA

Some few short years have passed away
 We've many changes seen
Since first we landed on the shores
 Of Canada, so green.
But now our lot in life is changed
 We can no longer stay
We have to speak our sad Farewell
 Farewell, Farewell, we say.

Fair Ottawa and Montreal
 Toronto and Quebec
We have watched them fading from our sight
 From off the steamer's deck.
But then, we had one cheering thought
 We to our friends could tell
We will return again to you
 Altho' we say Farewell.

But now, we leave them far behind
 'Tis for some distant shore
And see no prospect of return
 To visit them once more.
But as we leave you, we will ask
 May Earthly blessings dwell
On you and all our loving friends
 And we breathe our last Farewell

Charlie
1st, 60th R
Citadel, 10th Nov., 1871.[21]

The next day, the last troopship carrying away the last Imperial garrison raised anchor and sailed off down the St. Lawrence River. Only a handful of Royal Engineers were left behind to finish supervising the completion of the Lévis forts along with a few commissariat staff of the military controller's department to finalize the transfer of the last of the military stores and barracks to the Canadian Militia.

Lieutenant-Colonel Martindale, William Carlile's friend and co-author of *Recollections of Canada,* wrote these parting words:

> All, as seen in that before us, is now peaceful and quiet enough at Quebec. The last of the autumn fleet are homeward bound... and off the point of the Island of Orleans, passing down by the south channel, H.M.S. the *Orontes* with the last garrison of Quebec. In our ears still linger the soft sad strains from the band, "Good-bye, sweethearts, good-bye." Farewell — but not we hope for ever; not we hope for long —farewell Canada, farewell Quebec.[22]

OPPOSITE — William Ogle Carlile, c.1871.
The St. Lawrence, Quebec.
[From *Recollections of Canada,* 1873.]

This is the likely the last sketch made by Carlile before leaving Quebec City. Taken from the glacis of the Citadel, it shows *HMS Orontes* in the distance at centre and Pointe Lévis to the right across the busy St. Lawrence River.

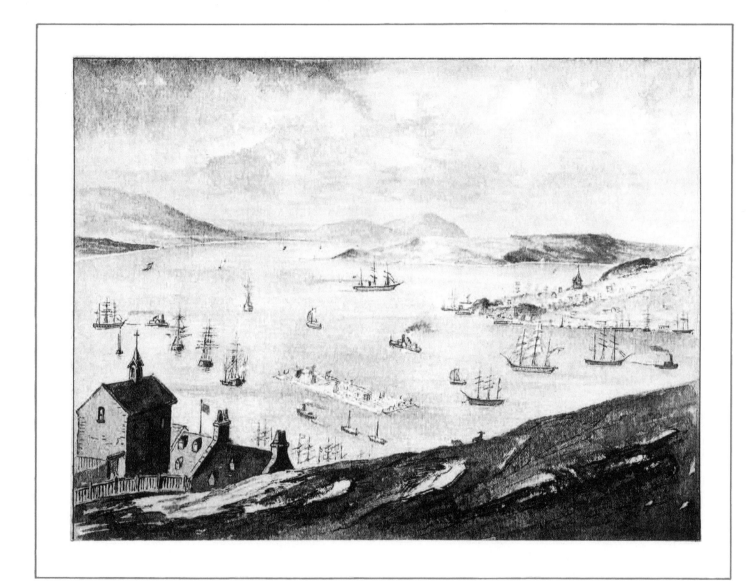

THE ST LAWRENCE, QUEBEC.

As hopeful as both the 60th Regiment's poet and Lieutenant-Colonel Martindale were that the British Army might, some day, return to defend Canada, that would never occur.

Three weeks after the last garrison was withdrawn from Quebec City, the London *Times* printed a complete and somewhat sympathetic summary of Canada's lengthy, reluctant transition to military independence; a transition from complete reliance on the Imperial garrisons to now being the sole provider of her own defence:

> The Canadians are accepting, it would appear, the departure of Her Majesty's troops from Quebec as the outward and visible sign of the revolution which has been made in the Colonial policy of England.... Hardly any soldiers of the Imperial Army are now left on Canadian soil. The departure from Quebec of the 1st Battalion of the 60th Rifles has especially moved the Canadians, and we cannot doubt that a certain painful wrench has been felt in achieving the separation. For the first time since the conquest of Canada, the Colony will be left to rely for its defence wholly upon its own resources....
>
> We can understand how keenly the Colonists feel what they believe to be the disruption of a bond which unites them to England. We can appreciate the sensation of nervousness and the natural hesitation which affect a new country with a sparse population and resources only in part developed when, after years of growth upon tutelage, it is bidden to embark on a career of independence, self government, and self-defence. The shock of separation, and of a sudden plunge into new duties and responsibilities, cannot but cause alarm and anxiety. But that shock sooner or later must have been encountered, and the Canadians would have been the last to put forward the discreditable pretext that they were unable to defend themselves, and were therefore unworthy of self-government.

Such a line of argument was, indeed, advanced before the close of the American Civil War, but the result of that great struggle taught, among various collateral lessons, that Canada, with its enormously lengthened frontier, exposed throughout its whole length to the attack of a powerful neighbour, could not be defended with success by British arms in the event of a war. It was agreed by politicians of every shade of opinion... that the Canadian frontier could not be protected against an invasion from the side of the United States by a force which England could possibly send across the Atlantic to repel the aggressors. The only hope of security for Canada lay evidently in the organization of a national force in the Colony, and it was quite evident from the experience of the past that such a force would never be organized so long as Great Britain maintained a single regiment in garrison or held a single fortress in Canada. The Canadians themselves appear to be aware of the necessity of the case, and when the proposal for a Confederation of the British Colonies in North America was brought before Parliament in 1867, the advantages of a Colonial military organization were eloquently urged. But as

soon as the Canadians had obtained a Confederation of the Provinces they showed no inclination either to give up the protection of the Imperial garrisons or to commence the laborious task of forming an army of their own.

Englishmen, however, could not be expected to bear much longer with patience the accounts of the prosperity of the Colonies for the defence of which they were paying while their fellow-citizens were contributing nothing to the military power of the Empire. Accordingly, even the Conservative Governments of Lord Derby and Mr. Disraeli were compelled to insist upon the gradual reduction of the Imperial forces in the Colonies. In spite of the slanders of party opponents, and the querulous remonstrances of short-sighted Colonists, this policy has been carried out, the murmurs of the discontented have died away, the Colonists are growing reconciled to a destiny they cannot evade and which is fruitful in possibilities of greatness. The withdrawal of the last Battalion of the British Army marks the commencement for the Canadian Dominion of a new career.[23]

There were some in Britain who seemed to think that all was well in the military affairs of the new Dominion as one London news magazine, *The Graphic,* postulated just a week later:

CANADA. — The regiment of the 60th Rifles has now left Quebec and the Canadians are thrown entirely upon their own military resources. The

Canadian forces, however, are well organised, and consist as follows: — 27 troops of Cavalry, 10 field and 70 garrison battalions of Artillery, 4 companies of Engineers, 639 of Rifles, and 612,467 Militia-men.[24]

While the numbers reported by *The Graphic* were more-or-less accurate, they did not tell the whole story. The "Militia-men", while great in numbers, were strictly an untrained force on paper that, if called up by a *levée en masse,* would be scrambling for rifles — only the first 6,000 of the 600,000 men could be provided with the mixed array of various makes and models of rifles and ammunition that were kept in reserve in the Canadian armouries[25] Canada would not have its own military small arms manufacturing capability until 1882,[26] so the vast majority of men of the Reserve Militia called up before then would have to wait for weapons to be supplied from the arsenals of Great Britain.

While the volunteers who made up the 43,000 strong Active Militia[27] were fully armed with serviceable rifles and artillery, their companies and battalions were not up to strength, and they had a minimal amount of training; only sixteen days each summer, at most. The rest of the year, these citizen-soldiers were occupied by their usual civilian employment. Furthermore, the Pacific coast colony of British Columbia, which had joined

the Canadian Confederation in July 1871, was almost completely devoid of troops; the nearest military aid being the tiny Canadian Militia outpost in Manitoba, 1,400 miles away through formidable mountains and across the trackless prairie.[28]

The closest thing to a standing army in Canada, other than a military administrative staff, were the 360 officers and men of "A" Battery and "B" Battery,[29] and most of them were only detached from their militia units for a maximum of twelve months (later increased to two years).[30] In the event of war against the only likely enemy, the United States, the Canadians would be quickly outnumbered by the 30,000 professional soldiers of the American army[31] together with the hundreds of thousands battle-hardened volunteers that could be quickly raised as had been done just a few years earlier during the American Civil War. Nevertheless, now fully responsible for their own defence, the part-time Canadian Militia, along with two permanent batteries of artillery at its core, was pushed into the role of a national army.

Ultimately, the war that so many had feared for so long, and for which so many had prepared, never came. The United States, concerned more about westward expansion than northern invasion, proved to be a peaceable neighbour and a strong trading partner.

In the end, it is, perhaps, the sparrows, kept as pets of the Royal Artillery at the ordnance park in Quebec City, which best articulated, metaphorically, the feelings of Canadians as expressed in a poem appearing in the *Volunteer Review and Naval and Military Gazette* one month after the departure of the last Imperial garrison:

THE COMPLAINT OF THE SPARROWS AT
THE ROYAL ARTILLERY PARK

Suggested by seeing a flock of them flying round and round, in evident distress, after the closing up of the Royal Artillery park.

The sparrows were brought from England by Colonel Rhodes two or three years ago and have ever since been carefully looked after and petted by the men of the Royal Artillery who provided them quarters in the Artillery Park.

[excerpts]

Dear friends and fellow Sparrows,
I've some weighty words to say
As they affect our future prospects
Stand "Attention" here I pray:

I've whirled about the Park
I've whistled "where, oh where"
There's a terrible big desertion
To me seems very clear...

And our Royal Park
Where we've so happy been
Cared for and loved and petted
By the big guns of the Queen

Is like a silent graveyard
With monuments of shame
For England and her honor
Will be an empty name

When she deserts her children
Her strength, her pride, her fame
And allows the "mighty dollar"
With "sordid" her name to stain...

Don't hop with angry twitterings
At what I now have said
Matters are very serious
They affect our daily bread

Let's fly to Colonel Rhodes
And tell him about our cheer
He never meant *desertion*
When he brought us over here

And if something isn't done
Starve we surely will
For since the "Orontes" sailed,
Not a crumb's been inside my bill.[32]

Anonymous

E. L'Heureux Livernois & L. Fontaine dit Bienvenu, c.1871.
Artillery Park
[Courtesy of Bibliotheque et Archives Nationale du Québec, E6/S8/SS6/P46-Quebec-Fortifications]

In this photograph of the Royal Artillery's Palace Gate barracks and artillery park at Quebec City, a soldier on the ramparts appears to be watching the activities in the barrack yard where children are playing among the gunners who are performing their duties. To the left, standing in the doorway of the barracks, is a woman, likely a soldier's wife, holding a baby.

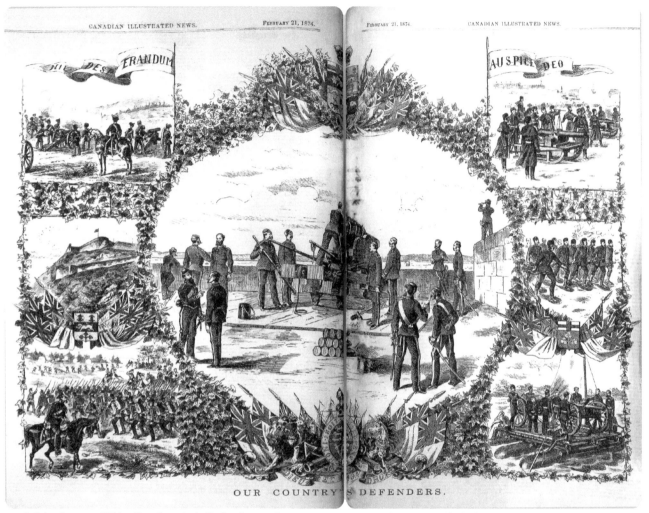

Artist unknown, 1874. **Our Country's Defenders.** [*Canadian Illustrated News*, 21 February 1874.]

"We have produced the double page 'Our Country's Defenders' purposely to stimulate an interest in our militia which has of late been almost criminally neglected. Our sketches are to life, having received the approval of competent authorities and we are in hope that it will partially attain the laudable object which we had in view."

[*Canadian Illustrated News*, 21 February 1874, p.123.]

Epilogue

Through the rest of the 19th Century and well into the 20th Century, Canada would rely largely on its part-time volunteer militia for home defence, with its tiny permanent force continuing to serve as the professional cadre of soldiers acting as schools of instruction and manning the forts left empty by the British Army. From the original compliment of 360 officers and men composing "A" Battery and "B" Battery in 1871, the regular army grew slowly.

During lengthy periods of peace, the Militia would largely be neglected, both by Canadian governments that wanted to reduce defence spending, and by the Canadian public for whom military affairs were only a matter of concern during times of imminent danger. However, by 1883, a third artillery battery, to be based on Vancouver Island, was authorized as an addition to Canada's permanent force. That year the Dominion Artillery was honoured by Queen Victoria who bestowed on them a new name, the Royal Regiment of Canadian Artillery. The permanent force was also expanded to include three companies of infantry and one troop of cavalry, increasing the regular army establishment to 788 officers and men.[1]

By the beginning of the 20th Century, Canada's professional army had more than tripled in size, to 2,730 soldiers,[2] and it would slowly increase over the decades. By 2020, the size of the regular Canadian Army had grown to 35,000 professional soldiers. These soldiers, together with 30,000 sailors and airmen in the Royal Canadian Navy and Royal Canadian Air Force, supported by another 30,000 reservists,[3] form the modern Canadian Armed Forces .

William Ogle Carlile, along with his bride Louisa, and the troops aboard *HMS Orontes* departing Quebec in November 1871, sailed up the St. Lawrence River, through the Gulf of St. Lawrence, and past Prince Edward Island and Cape Breton Island to the "Imperial station" at

Halifax, Nova Scotia, where they would reside for the next fifteen months. On the voyage to Halifax, William produced several sketches, some of which were published in the *Canadian Illustrated News* and *L'Opinion Publique* over the following years.

At Halifax, William continued to paint and draw and enjoy the social life of an officer in a peacetime garrison, performing in amateur theatricals, attending garrison balls and going on hunting expeditions in the forests of Nova Scotia. Soon after arriving, he and his friend Lieutenant-Colonel Ben Martindale prepared the manuscript for their book *Recollections of Canada*, with illustrations by Carlile and text by Martindale. The manuscript was accepted by the London publishers, Chapman & Hall, who were advertising the book's availability in Canada and in Britain by the end of 1872.

In announcing the book, the *Canadian Illustrated News* mentioned Martindale as "thoroughly competent", and Carlile as "a careful and gifted artist".[4] The book, however was met with qualified reviews on both sides of the Atlantic Ocean. London's *Pall Mall Gazette* pronounced it as "...merely recollections of a pleasant garrison time,"[5] and the *London Daily News* commented that "...the sketches are rapidly and slightly executed, but are spirited, lively and effective."[6] The *Quebec Daily Mercury* was more effusive, writing that, "We have no hesitation in pronouncing the work one of the most interesting volumes relating to Canada we have yet met with, and it reflects the highest credit upon its authors."[7]

At the beginning of 1873, the 3rd Brigade was ordered home to England; replaced at Halifax by three batteries of the Royal Artillery's 7th Brigade. On February 5, William and Louisa embarked on the troopship *HMS Himalaya* along with the 3rd Brigade's other soldiers and their wives and children. After stopping at Bermuda for eight days, giving William the opportunity to produce more sketches, the ship proceeded to Plymouth, then Portsmouth, and finally to Gravesend where Lieutenant Carlile and the other officers and men of No. 5 Battery disembarked on March 6.[8]

OPPOSITE — William Ogle Carlile, 1872.
Halifax - The Midday Gun.
[*Canadian Illustrated News*, 11 May 1872).]

This is a view of Halifax from the saluting battery on Citadel Hill showing the clock-tower to the left of centre and the city below with the harbour in the background. In addition to manning the guns at the Halifax Citadel, the Royal Artillery was responsible for batteries at several other locations including George's Island, and York Redoubt.

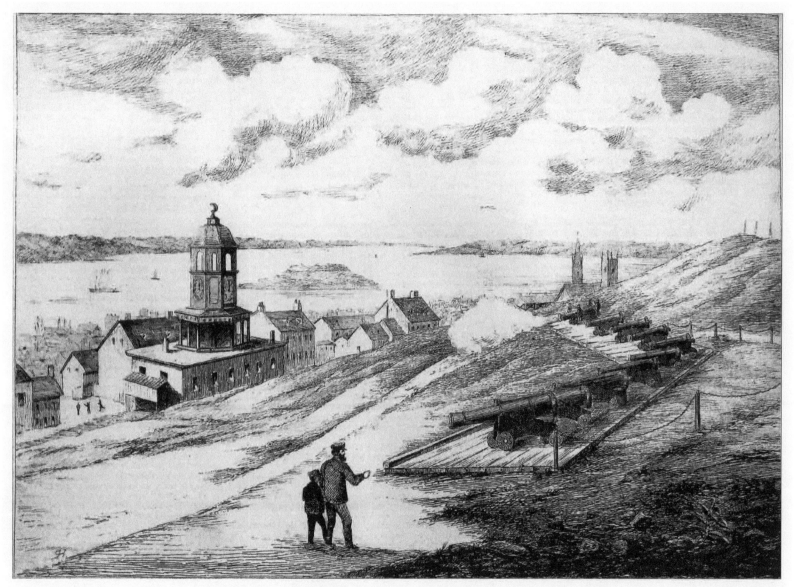

HALIFAX — THE MIDDAY GUN. FROM A SKETCH BY W.O.C.

Twelve years earlier, Lieutenant Carlile had left England aboard *Himalaya* as a newly-minted artillery officer. It was on the same ship that he returned as a seasoned military professional. On arriving back in Britain, we can imagine that he would have immediately gone on leave in order to take his bride to Ireland and introduce her to his family, but the historical record is silent on that issue. We do know that immediately after arriving, No. 5 Battery went into barracks at Woolwich. Soon afterwards, the battery was sent to garrison the newly-constructed Newhaven Fort on England's south coast.[9]

William's reputation as a "careful and gifted artist" had been noticed by the editors of the popular British magazine, the *Illustrated London News*. As early as 1870, one of his illustrations of the fire at Quebec had been published in the magazine, and a series of six of his drawings done aboard the *Himalaya* were featured in the magazine's pages in 1873[10] (one shown opposite).

In 1874, Carlile was promoted to captain and transferred to the 17th Brigade at Gibraltar, then commanded by his former commanding officer, Lieutenant-Colonel Reginald Farmer. In 1880, Captain Carlile was posted to Jamaica where he spent a year before being promoted to major and sent back to Gibraltar. In 1885, he was moved again. This time back to Royal Artillery Headquarters at Woolwich.[11]

When the Government of Canada decided to participate in the Colonial and Indian Exhibition held in London in 1886, they chose works representative of "Canadian" art. Paintings by a number of artists such Cornelius Krieghoff, Thomas Mower Martin, Lucius O'Brien, Frederick Verner and Homer Watson were displayed in the gallery of the Royal Albert Hall. Included among the artwork of these well-known artists was one

OPPOSITE — William Ogle Carlile, 1872.
Life On Board a Troopship: Heaving the Log.
[*Illustrated London News*, 29 November 1873.]

"The experiences of soldiering in the British Army differ from those of every foreign military service. Though enlisted in Her Majesty's land service, it is the lot of almost every private or non-commissioned officer in a regiment of the Line or in the Royal Artillery to pass many weeks or months in long sea voyages, either to and from India, or between this country and the seat of a distant war....

"During the first days of the voyage, however, especially with troops who have not been at sea on any former occasion, the soldier finds himself rather puzzled by the novel conditions of his daily life.... The officers, indeed, knowing that idleness would do their men no good, will set and keep them to such employments as they are fit to share in the work of the ship.

"Our illustrations of these incidents are from sketches by Lieutenant W.O. Carlile, R.A."

[*Illustrated London News*, 29 November 1873, p, 3.]

LIFE ON BOARD A TROOP-SHIP: HEAVING THE LOG.

oil painting by William Ogle Carlile — a view of the gunners of No. 5 Battery on snowshoes titled "Route Marching In Canada."[12] One of Carlile's images that had appeared in the *Canadian Illustrated News* fifteen years earlier, "The Royal Artillery on a Snow Shoe Tramp Near Quebec" (opposite), was likely a Leggotype version of this painting.

William retired from the British Army in 1887 with the honorary rank of lieutenant-colonel. He and Louisa then settled in the English town of Fleet, Hampshire. Twenty years later, at sixty-five years of age, William Ogle Carlile died at Fleet in 1907.[13]

As for his original paintings and drawings on which the illustrations in his book and in the news magazines were based, their whereabouts remain a mystery. They are likely tucked away, forgotten at the bottom of a trunk in some family attic, or perhaps stacked, unlabelled, in some obscure museum storage facility waiting to be rediscovered and brought to the attention of the general public. Thankfully, printed versions of some of Carlile's artwork have survived.

The withdrawal of the last Imperial garrison defending Canada in 1871 had sown the seeds for the establishment and growth of the country's own permanent defence force. The British government's insistence on removing all of its troops with the exception of a small garrison at Halifax,[14] not only became the catalyst for the creation of a standing army in Canada, but it became an important stepping stone to Canada's eventual full independence from Great Britain and the British Empire.

The artwork of William Ogle Carlile continues to provide a unique, contemporary, graphic view of those pivotal times in Canada's history.

OPPOSITE — William Ogle Carlile, 1871.
The Royal Artillery on a Snow Shoe Tramp Near Quebec
[*Canadian Illustrated News*, 25 February 1871.]

Carlile's original work on which this published image was based was likely his painting titled "Route Marching In Canada" which was displayed as part of the Canadian exhibit of the Colonial and Indian Exhibition of 1886.

"In this issue we present a sketch of the Royal Artillery at Quebec on a snow-shoe tramp near that city. The view was taken by the artist near Bijou, going towards the St. Charles River. The Artillery go out every week for a march in snow-shoes, to keep themselves in training, we suppose, for the efficient performance of their duty in the event of a winter campaign....

"We understand that this exclusively wintery, and peculiarly Canadian, exercise of tramping in moccasins and snow-shoes is never imposed upon the troops when the thermometer ranges below Zero [Fahrenheit]"
[*Canadian Illustrated News*, 25 February 1871, p. 115.]

THE ROYAL ARTILLERY ON A SNOW SHOE TRAMP NEAR QUEBEC. FROM A SKETCH BY W.O.C.

APPENDIX A

BRITISH TROOPS IN NORTH AMERICA
1850-1871

YEAR	NUMBER OF TROOPS	
1850	8,800	
1851	6,900	
1855	3,200	(Crimean War)
1856	7,000	
1858	4,500	
1861	7,500	(U.S. Civil War begins)
1862	19,500	("*Trent* Affair")
1863	17,500	
1865	12,000	(U.S. Civil War ends)
1866	15,000	(Fenian raids begin)
1868	13,000	
1869	4,000	(Final decision to withdraw)
1871	2,000	(at Halifax)

APPENDIX B

ORDER-IN-COUNCIL
1871-1446

[Library and Archives Canada, RG2, Privy Council Office,
Series A-1-a volume 291, Reel C-3298]

The Committee of Council has had under consideration the annexed Report from the Adjutant General, concurred in by the Hon. the Minister of Militia and Defence, submitting certain regulations for the maintenance and equipment of two Batteries of garrison artillery, for which an appropriation was made by Parliament at its last session, and they respectfully advise that the said annexed Report be approved by Your Excellency.

John A. Macdonald

19 Oct /71

Appvd

\mathcal{L} [John Young Baron Lisgar]

MILITIA GENERAL ORDERS.

[Excerpts from General Order 24. *The Canada
Gazette*, No. 17, Vol. V, Ottawa, Oct. 21, 1871.]

HEAD QUARTERS,
Ottawa, 20th October, 1871

General Orders (24)

No. 1.

Batteries of Garrison Artillery.

An appropriation having been sanctioned by Parliament for the pay, maintenance and equipment of two Batteries of Garrison Artillery, in order to provide for the care and protection of the Forts, Magazines, Armament and Warlike Stores, recently, or about to be handed over to the Dominion Government, in the Provinces of Ontario and Quebec, the formation of these Batteries is hereby authorized.

No. 2.

Schools of Gunnery.

It is further intended that these Batteries, in addition to performing Garrison duties, shall serve as practical Schools of Gunnery for the training of all ranks of the Militia artillery, viz: — by instructing Gunners and Drivers and affording officers and non-commissioned officers opportunities of joining long or short Courses of Instruction as may best suit them individually.

No. 3.

SCHOOL OF GUNNERY, KINGSTON.

A Battery, to be designated "A" Battery, will be formed by taking Volunteers from the existing Batteries of Field and Garrison Artillery in the Province of Ontario — the maximum strength of which is to be as follows: —

 1 Captain.

 3 Lieutenants.

 1 Assistant Surgeon.

 1 Battery Sergeant-Major.

 1 Laboratory Foreman.

 1 Ordnance Armourer.

 1 Master Gunner.

 6 Sergeants.

 4 Corporals.

 4 Bombardiers

 3 Trumpeters.

110 Gunners.

 8 Horses. — (for instruction in riding, driving, moving field and siege guns, and general purposes.

"A" Battery will furnish a detachment of the following strength for duty at Toronto: —

 1 Lieutenant.

 1 Sergeant.

 1 Corporal

 1 Bombardier

 1 Trumpeter

 20 Gunners

No. 4.

SCHOOL OF GUNNERY, QUEBEC.

A Battery, to be designated "B" Battery, will be formed in a similar manner from existing Batteries of Field and Garrison Artillery in the Province of Quebec — the maximum strength of which is to be as follows, (so long as the forts at Point Levis remain unarmed):

 1 Captain.

 4 Lieutenants.

 1 Assistant Surgeon.

 1 Battery Sergeant-Major.

 1 Laboratory Foreman.

 1 Ordnance Armourer.

 1 Master Gunner.

 6 Sergeants.

 6 Corporals.

 4 Bombardiers

 3 Trumpeters.

130 Gunners.

 8 Horses. — (for instruction in riding, driving, moving field and siege guns, and general purposes)

This Battery will furnish the following detachments, until further orders:

FOR THE FORTS AND ENGINEER PARK AT POINT LEVIS.

 1 Non-Commissioned Officer

 10 Gunners

FOR ST. HELEN'S ISLAND, MONTREAL.

1 Lieutenant.
1 Sergeant.
1 Corporal
1 Bombardier
1 Trumpeter
20 Gunners

No. 5.

Pay

The rates of pay of officers, non-commissioned officers and men of these batteries to be as follows:

	Per diem
Captain	$2 82
Lieutenant	1 58
Assistant-Surgeon	2 43
Battery Sergeant-Major	1 00
Laboratory Foreman	1 00
Ordnance Armourer	1 00
Master Gunner	1 00
Sergeants	0 80
Corporals	0 70
Bombardiers	0 60
Trumpeters	0 50
Gunners	0 50

No. 6.

Ration and allowances.

In addition to the above rates of pay, each officer, non-commissioned officer and man will receive a daily ration free of cost, of 1 lb. of meat and one pound of bread, together with barrack accommodation, and the usual quantity of fuel and light allowed in the regular army; and the commandants of the schools, in addition, forage for one horse.

No. 7.

Selection of non-commissioned officers and men.

The non-commissioned officers and men to form A and B batteries will be selected from those belonging to the Militia Artillery of the Dominion who may voluntarily engage therein for twelve months duty. Men desirous of joining A and B batteries who are not enrolled members of any corps, or who belong to other than artillery corps of the Active Militia, may also, if approved, be appointed to A and B Batteries.

No. 8.

Short course of Instruction.

On the formation of the Batteries, five officers and five non-commissioned officers (previously recommended) will be directed to join each school of Gunnery for a short course of instruction, to last three months; on the termination of which the Commandants may select from these officers and non-commissioned officers, one

or more of the most efficient and retain them for an additional course of nine months, or for a further period, should it be considered that the service would be benefited by affording them a full course of instruction.

Officers and non-commissioned officers, so selected, will receive instruction, in addition to Field and Garrison Artillery Exercises, in the mode of making rafts, military bridges, &c., pontooning, formation of Field works and Batteries, laying Gun and Mortar Platforms, &c., &c. Those officers and non-commissioned officers who, on conclusion of the "short course," are retained for the long course of instruction, will be taken on the strength of A and B Batteries, and will then receive the pay of their ranks, with the usual allowances, but in no case is the establishment of officers and non-commissioned officers of A and B Batteries to be exceeded. On the termination of the first short course, similar short courses will be continued, from time to time, if found desirable, due notice of which will be announced in General Orders.

... No. 16.
Liable to duty in any part of Dominion.

All officers, non-commissioned officers and men belonging, or attached to A and B Batteries will be liable to duty if required, in any part of the Dominion of Canada, for the whole or any portion of the period, they may be on the strength of these Batteries.

No. 17.
Commandants of Schools.

Lt. Colonel G.A. French, the Dominion Inspector of Artillery, will be the Commandant of the School of Gunnery at Kingston. The instruction, drill, and discipline to be carried out under the supervision of that officer. The Commandant of the School of Gunnery at Quebec will be an officer of the Royal Artillery, (to be nominated hereafter), who has qualified at the School of Gunnery, Shoeburyness, England, and whose services will shortly be placed at the disposal of the Dominion Government by the Imperial authorities; and he will in like manner be charged with the instruction, drill, and discipline to be carried out in that School. As the Dominion Inspector of Artillery will frequently be called away from Kingston to attend to his other duties, an Assistant Gunnery Instructor (to be nominated hereafter) will be allowed for the School of Gunnery there. This officer will receive the pay and allowances of a Major, he will be available for the instruction of Militia Batteries at out-Stations for general purposes, and will command the Schools of Gunnery, Kingston, in the absence of the Inspector of Artillery.

No. 18.
Command.

The above Schools of Gunnery, with any detachments therefrom, are placed under the immediate Command of their Commandants who will report direct to Head Quarters, and receive instructions solely from the Adjutant-General.

... No. 20.

Forts, &c., handed over to Commandants.

The Director of Stores and Keeper of Militia properties is herby instructed to hand over, as soon as convenient, to the Commandant of the School of Gunnery at Kingston, the whole of the Forts with the armament and stores hitherto in charge of the Officer Commanding the Royal Artillery at that station, also the whole of the quarters for officers, non-commissioned officers, and men, guard rooms and other buildings at the *Tete du pont* Barracks, the buildings contained in the new Fort, Toronto, and stores at the old Fort, when required. The Forts and Works at Quebec and Point Levis, with the armament and stores about to be handed over by the Royal Artillery, will in like manner be transferred to the care of the Commandant of the School of Gunnery at Quebec, also the Barracks with the mounted guns and stores connected therewith at St. Helen's Island, Montreal.

No. 21.

Schools of Gunnery — St. John and Halifax

Arrangements are being made for the formation of Schools of Gunnery at St. John, N.B., and Halifax, N.S., the details of which will be announced hereafter in General Orders.

By Command of His Excellency the Governor General,

P. ROBERTSON-ROSS, Colonel, Adjutant-General of Militia, Canada.

Notes

CHAPTER 1 Background – The Colonial Garrisons

1. See William L. Grant, "Canada versus Guadeloupe", *American Historical Review,* vol. XVII, No. 4, July 1912.

2. See Seidle and Massicotte, *Taking Stock of 150 Years of Responsible Government in Canada*, Ottawa, 1998. pp.8-10.

3. Statement of the Earl de Grey quoted in a letter from Edward Cardwell to Earl Granville, Jan, 25, 1869, from *Returns to Addresses of the Senate and House of Commons, Relative to the Withdrawal of the Troops from the Dominion and on the Defence of the Country,* Ottawa, 1871, p.5.

4. Troops in the Province of Canada were reduced from 6,106 to 4,960. Troops in Nova Scotia were reduced from 2,697 to 2,026. C.P.Stacey, *Canada and the British Army 1846-1871*, p.85.

5. 1,887 regulars remained in the Province of Canada and 1,086 remained in Nova Scotia with another 311 in Newfoundland. Stacey, ibid, p.90.

6. North American military expenditures in 1853-54 had been £464,056, reduced to £227,647 in 1855-56.
J. Mackay Hitsman, *Safeguarding Canada 1760-1871*, tables p.231-232, "British Expenditure in North America Out of Army Funds" and "Effective Strength of the British Army in North America, 1860-1869", taken from UK National Archives, W.0.17, Monthly Strength Returns.

7. See G.F.G. Stanley, *Canada's Soldiers*, 1960, pp.214-216.

8. Letter from Edward Cardwell to Earl Granville, *Returns to Addresses ... Relative to the Withdrawal of the Troops,* Jan, 25, 1869, ibid.

9. Stacey, ibid, pp.97-99.

10. In 1858, Britain's War Office spent £452,000 while Nova Scotia and the Province of Canada combined spent only £40,400. Stacey, ibid, p.112.

11. Hitsman, ibid., p.232

12. A total of 1,380 incidents of blockade running were listed in British records. Of these, 230 incidents involved ships that were either British registered or were arriving from or departing to British ports. Great Britain, Foreign Office. *Papers relating to the blockade of the ports of the Confederate States*, London, 1862.

13. Ship manifests: GRAND TOTAL: 3,054 soldiers
and 180+ women, 165+ children
GREAT EASTERN
Battery No. 4 ("D" Battery), 4th Field Brigade – 7 officers, 220 men, 20 women, 25 children, 110 horses Total: 227 soldiers.
30th Regiment – 39 officers, 868 men, 80 women, 120 children, 6 horses Total: 907 soldiers
4th Battalion, 60th Rifles – 39 officers, 868 men, 80 women, 120 children, 6 horses Total: 907 soldiers
Various (16th, 17th, 100th, RC Rifle regiments) – 4 officers, 102 men, 9 women, 19 children Total: 106 soldiers

GOLDEN FLEECE:
47th Regiment – 39 officers, 868 men, women, children, horses
Total: 907 soldiers
Morning Advertiser - Thursday 13 June 1861, London. p.3

14. "The Defences of New York", *New York Times*, 18 Oct. 1861, p.4.

15. *The Evening Standard,* London, Wed. 27 Nov. 1861, p.4.

16. *The Morning Chronicle,* London, 29 nov. 1861, p 5.

17. See Amanda Foreman, *A World On Fire*, New York, 2010, pp.183-185.

18. 17,733 troops as of April, 1862 and a cost of £939,424 for the fiscal year 1861-62, compared to £295,612 for the previous fiscal year. Hitsman, *ibid.*

19. Hansard, U.K. Parliament: Volume 165: Resolution, Commons Chamber, Tuesday 4 March 1862.

20. See Fortescue, v.13.

21. "Report of a Committee of the Executive Council of the Province of Canada to Governor-General Viscount Monck, 30 Oct. 1862", Sessional Paper No. 63, *Sessional Papers of the Dominion of Canada, Session 1867-8,* pp.63-1 to 63-8 supplementary. Ottawa, 1868. See also Newcastle/Monck 1862 correspondence, pp.63-3 to 63-10.

22. *Report of the Commissioners Appointed to Consider the Defences of Canada*, London, 1862, p.5.

23. By April, 1865, there were 12,522 British regulars in North America. One year later, that number had dropped to 12,109. Hitsman, ibid.

24. See Adrian Cook, *The Alabama Claims: American Politics and Anglo-American Relations, 1865-1872*, London, 1975. pp.62-82.

25. For a concise summary of the Fenian movement see James Zibro, "The Life of Paddy Yank", PhD dissertation, Catholic University of America, Washington, D.C., 2016.

26. For a full account of the Fenian Raids see John Macdonald, *Troublous Times In Canada*, Toronto, 1910.

27. 11,923 soldiers in the Province of Canada plus 3,678 in the Atlantic provinces as of April, 1867. Hitsman, ibid.

28. Expenditures in the fiscal year 1865-66 by the Province of Canada for the "Frontier Force" amounted to $1,123,986 over and above the general militia expenses.
"General Statement of Expenditure", Sessional Paper No. 12, *Sessional Papers of the Dominion of Canada 1867-8,* p.131.

29. The War Office expended £616,502 on its troops in the Province of Canada during 1865-66 (including £56,093 on fortifications). This was the equivalent of $2,959,209 in 1866 Canadian dollars. Hitsman, ibid, p.231.

30. Report of the Executive Council of the Province of Canada to Governor-General Viscount Monck, 30 Oct. 1862. Appeared in "Return to an Address of the House of Commons date 18th March 1868… on the subject of Colonial Military Expenditure and Military Defence of the Late Province of Canada", *Sessional Paper No. 63, Session 1867-68,* Ottawa, 1868, p.546

31. At both the Charlottetown Conference and the Quebec Conference, Newfoundland sent representatives as observers only. The Pacific coast colonies of Vancouver Island and British Columbia were not represented at all.

32. The vote was 91-33 in favour of adopting the seventy-two resolutions: 54 of the 62 Canada West members of the legislature voted yea, and 37 from Canada East voted yea, including a majority of the French-Canadian members.
P.B. Waite (ed.), *The Confederation Debates in the Province of Canada, 1865*, Toronto, 1963, p.18.

33. Report to Viscount Monck, 12 July 1865, printed in SP 1867-8, vol. 9, No. 63, Ottawa, 1868, pp.11-16.

34. *The Times*, London, March 29, 1867, p.9.

35. In 1870, a small contingent of two companies of Royal Engineers was sent to Canada to replace two companies returning to Britain. The Toronto *Globe*, 26 May 1870, p.2.

CHAPTER 2 William Ogle Carlile

1. Until the practice was abolished in 1871, most officers' commissions in the British Army were purchased. See Anthony Bruce, *The Purchase System in the British Army 1660-1871*, London, 1980.
In the British Army of the mid-19th Century, only a small number of officers were granted commissions without purchase after attending a rigorous course of study at either the Royal Military College, Sandhurst (for infantry and cavalry officers) or the Royal Military Academy, Woolwich (for artillery and engineer officers). Using a conservative "GDP deflation index", £450 in 1859 would be the equivalent of about £49,200 in 2021. The pound sterling to Canadian dollar (CDN$)exchange rate in 2021 was about $1.70. Therefore, £450 in 1859 would have had similar buying power to about US$83,640 in 2021, a factor of 185.87X. A factor of 185x is used in all similar monetary comparisons in this book.
See Lawrence H. Officer and Samuel H. Williamson, "Five Ways to Compute the Relative Value of a UK Pound Amount, 1270 to Present," MeasuringWorth, 2020, URL https://www.measuring- worth.com /uk-compare/ result.php?year_source=1859 &amount=500& year_result=2019#, accessed 14 January, 2021.

2. £101.10s. was the allowance granted to an infantry subaltern on active service who had to re-equip himself in the field after the loss of a substantial portion of his military gear due to enemy action.
See Edward Barrington de Fonblanque, *Treatise on the Administration and Organization of the British Army*, London, 1858, p.291.

3. £125 equates to CDN$23,125 in 2021.
Hart's Annual Army List, London, 1863. p.475.
If he were on active service, an officer's regular pay would be supplemented by "field allowance" of one extra shilling (CDN$9.25 in 2021) per day. See, letter, War Office to General Officer Commanding the Troops, Halifax, N.S., 24 Dec. 1861, LAC RG8 C-series microform c-3843/1730-92.

4. "The Pay and Expenses of Officers", *Colburn's United Service Magazine*, Part I, London, 1861, pp.317-328.

5. Gentlemen-Cadets at RMA Woolwich received an allowance of 2s. 6d. per day (CDN$23.12) which they used to pay for their food. See F.G. Guggisberg, *"The Shop"*, London 1900.
See also, Royal Artillery Institution, *List of Officers of the Royal Regiment of Artillery*, Woolwich, 1869.

6. *Cork Examiner*, Aug.2, 1859, p.3.

7. "French View of Our Military Colleges", *Colburn's United Service Magazine*, 1860-Part III, London, 1860. pp.367-368.

8. Photography was introduced as a "voluntary class" at RMA Woolwich in 1865.
H.D. Buchanan-Dunlop, *Records of the Royal Military Academy Woolwich*, London, 1892, p.114.

9. Hart's Annual Army List, London, 1863. p.473

10. Guggisberg, *ibid.*, pp.91-93.

11. More officers in the British Army of the 1860's came from Ireland than from any other part of the British Isles, except for England. Of the 182 cadets that were granted commissions between July, 1861, and August, 1864, 30 were from Anglo-Irish families, representing 15% of the RMA Woolwich graduates. Of the 182 officers listed in this one Record Book, 49% were born in England, 15% in Ireland, 9% in Scotland, and 2% in Wales. The remaining 25% were born outside of the United Kingdom including 7% in India, 2% in Canada, 2% in Australia and 2% in the West Indies.

12% were born in other countries or their place of birth was not recorded. Colonel Garnet Wolseley who commanded the Red River Expedition in 1870 was another Anglo-Irish officer in the British Army.
See War Office, "Record Book of Officers' Services", U.K. National Archives, PRO 76/370.

12. Roderick C. Macleod, "French, Sir George Arthur," in *Dictionary of Canadian Biography*, vol. 15, University of Toronto/Université Laval, 2003–http://www.biographi.ca/ en/bio/french_george_ arthur_15E.html, accessed April 15, 2021,

13. See Patrick Irwin, *An Army Officer's Life in Canada*, Montreal, 1992.

14. A single Coast Artillery Brigade also existed for a short time for service in the British Isles, but was eventually amalgamated with the Garrison Artillery.

15. At this time, individual Horse Artillery batteries and Field Artillery Batteries were identified by letters A through H, while Garrison Artillery batteries were numbered 1 through 8.
See Charles Callwell and John Headlam, *The History of the Royal Artillery,* Vol I, Woolwich (facsimile edition).

16. Captain Francis Maude CB, and Second-Captain C.C. Teasdale CB were awarded the Victoria Cross for heroism in two separate actions.
H.G. Hart, *New Annual Army List and Militia List 1862*, London, 1862, pp.167, 168.

17. Alfred Lord Tennyson, "Ode on the Death of the Duke of Wellington", London, 1852.

18. The five batteries that initially disembarked at Valetta in 1861 were later joined by batteries No. 6, 7, and 8 which were moved from Corfu to Malta in 1864, after the British Protectorate of the Ionian Isles was ended and the islands were handed over to the government of Greece.
See M.E.S. Laws, *Battery Records of the Royal Artillery 1859-1877*, Woolwich, 1970. p.1864, note A.

19. Frederick Harris D. Vieth, *Recollections of the Crimean Campaign and the Expedition to Kinburn in 1855,* Montreal, 1907. pp.19-20.

20. Nos. 2, 3 and 4 Batteries went into barracks at Quebec City on July 29, 1867. On her return voyage from Canada to the Mediterranean with the 10th Brigade, *Simoom* disembarked No. 1 Battery at St. John's and then continued on to Malta.
M.E.S. Laws, ibid., pp.1867 and notes.

21. *Morning Chronicle Commercial and Shipping Gazette,* Quebec, 4 Oct. 1867. p.3.

CHAPTER 3 Carlile at Monreal and Ile aux Noix

1. Lieutenant Carlile's movements have been pieced together from newspaper reports(See *Quebec Morning Chronicle*, 7 Oct. 1867, p.2) together with details from M.E.S. Laws, *Battery Records of the Royal Artillery 1859-1877.*

2. This is inferred by an announcement in the *Quebec Daily Mercury*, 19 June 1868, p.2.

3. M.E.S. Laws, ibid., pp.1871-1872, note 82.

4. Correspondence, Lt. W.O. Carlile, RA, and Capt. W.L. Melville, RCRR, 20 Oct. 1867, LAC RG8 "C" Series MF765, p.94.

5. Greville J. Chester, *Transatlantic Sketches,* London, 1869, p.289.

6. Francis Duncan, *Our Garrisons in the West*, London, 1864, p.255.

7. Ibid., pp.165-169

8. See Elinor Kyte Senior, *Roots of the Canadian Army*, Montreal, 1981.

9. Duncan, ibid, p.59.

10. See W.A. Leggo, *La Leggo-Typie: Procédé photo-électrotypique breveté au Canada, aux Etats-Unis, en Angleterre, en France et en Belgique*, Ottawa, 1867.

11. "Prospectus", *Canadian Illustrated News*, Montreal, 1869, p.1.

12. See Albert Moritz, *Canada Illustrated*, Toronto, 1982.

13. More than 2,000 images of original artwork printed in the pages of *L'Opinion Publique Journal Illustré* and the *Canadian Illustrated News* are unattributed or attributed only to "Our Special Artist". It is likely that several of these images were contributed by W.O. Carlile.

CHAPTER 4 The Final Decision

1. *First Reading of a Bill Respecting the Militia and Defence of the Dominion of Canada*, House of Commons, Ottawa, March 31, 1868, p.1.

2. ibid.

3. Order-in-Council Number 1868-0863. LAC RG2, Privy Council Office, Series A-1-a., volume 261, Reel C-3289.

4. "Report to His Excellency Sir John Young, Governor General of Canada", *Fortifications and Defence, Arms, &c.*
Ottawa, 20 May 1869, p.2.

5. *First Reading of a Bill Respecting the Militia and Defence of the Dominion of Canada*, House of Commons, ibid.

6. Edward Cardwell, "Paper on Army Reform", in Robert Biddulph, *Lord Cardwell at the War Office*, London, 1904, Appendix 1.

7. Ibid, pp.5-6.

8. Speech by Edward Cardwell in the British House of Commons, reported in the Toronto *Globe*, 30 March 1869, p.1.

9. "Dispatch of the Secretary of State for the Colonies to the Governor-General, 14 April 1869, delivered to the Canadian House of Commons on 11 June, 1869". From SP Vol.5, No. 46, Sess. 1871, Ottawa, 1872, p.4.

10. Letter, Cardwell to Earl Granville, 25 January 1869, from SP Vol.5, No. 46, Sess. 1871, Ottawa, 1872, p.4.

11. *Quebec Morning Chronicle and Shipping Gazette*, 13 Nov. 1868, p.2.

12. The Toronto *Globe*, 29 April, 1869, p.2 and 10 May 1869, p.2. See also *The Vol. Rev and Mil. and Nav. Gazette*, 8 Feb. 1869, p.86.

13. *Volunteer Review and Military and Naval Gazette*, ibid.

14. *The Quebec Daily Mercury*, 17 June 1869, p.2.
The battery on St. Helen's Island was sent to Kingston.

15. The 13th Hussars were sent home to Britain as were four field batteries of the Royal Artillery's 4th Brigade, while three garrison batteries of the 1st Brigade were sent to Bermuda and the West Indies, four infantry battalions were sent home and two infantry battalions were sent to the West Indies.
The Volunteer Review and Military and Naval Gazette, Ottawa, 3 Apr. 1869, p.289, reprinted from *Broad Arrow.*

16. For the general defence of Canada, there were two batteries of field artillery (4th Brigade), four batteries of garrison artillery (3rd Brigade — three at Quebec and one at Kingston, not including one at St. John's, Newfoundland.), two companies of Royal Engineers (most of whom were at work on Quebec City's new forts at Pointe Lévis), three infantry battalions, and eight companies of the Royal Canadian Rifles (not including two companies stationed in Newfoundland).
Sent to the "Imperial station" at Halifax to defend the Royal Navy dockyard were three batteries of garrison artillery, two companies of Royal Engineers and two infantry battalions.
The Volunteer Review and Military and Naval Gazette, ibid.

17. A portion of the text in the *Canadian Illustrated News* that accompanies this image of *HMS Crocodile* is as follows:
"On Thursday, the 7th instant, H.R.H. Prince Arthur, after a ten months' stay in Canada, left for England in *H.M.S. Crocodile....* A detachment of the 69th Regiment were the guard of honour, and he was also escorted by the Quebec Hussars. The streets were decorated with flags and the enthusiasm of the citizens was vented in repeated cheers.... Every point overlooking the river was crowded with spectators and a large number of ladies. As he stepped into the launch, the Royal Standard was run up on the citadel, and the royal salute from 21 guns pealed forth."
Canadian Illustrated News, 23 July 1870, p. 51.

CHAPTER 5 Carlile at Quebec City and Pointe Lévis

1. B.H. Martindale and W.O. Carlile, *Recollections of Canada*, London, 1873. pp.21-23

2. R.L. Dashwood, *Chiploquorgan or Life by the Camp Fire in Dominion of Canada and Newfoundland*, Dublin, 1871, pp. 211-212.

3. This number does not include 21 marriages between Canadian girls and army staff officers or officers in the Royal Navy.
J.M. LeMoine, *Maple Leaves: Canadian History, Literature, Sport*, Quebec, 1873, pp.287-288.

4. *Morning Chronicle*, Quebec, 2 September 1871, p.2.

5. Known as the 95th Rifles during the Napoleonic Wars, the regiment was renamed the Rifle Brigade in 1815 and then renamed again in 1862 to the Prince Consort's Own Rifle Brigade, in memory of the late Prince Albert, Prince Arthur's father.

6. Eighty-seven of Carlile's known cartoons appeared in nine separate issues of the *Canadian Illustrated News* between January 1871 and February 1873. Another eleven of his cartoons were published in his book *Recollections of Canada* in 1873.

7. See Alan Clark and Laurel Clark, *Comics: An Illustrated History*, London, 1991.

8. The cartoons in this compilation were taken from eight separate issues of the *Canadian Illustrated News*:
His Skating Experience, 10 Feb 1872
His Tobogganing Experience, 24 Feb 1872
His Tandem Experience, 2 Mar 1872
A Snow-Shoeing Party, 6 Apr 1872
At an Evening Party, 4 May 1872
His Curling Experience , 18 Jan 1873
A Few Street Adventures, 8 Feb 1873
Dinner Not à la Russe, 15 Feb 1873.

9. *The Quebec Daily Mercury,* 16 April 1869, p.2.

10. See, *The Queen's Regulations and Orders for the Army*, London, 1859.

11. See David Facey-Crowther, 'The British Army and Aid to the Civil Power in North America, 1832-1871", *Journal of the Society for Army historical Research*, Winter 2015.
See also Alan Greer, "Birth of the Police in Canada", *Colonial Leviathan*, Toronto, 1992.

12. *Canadian Illustrated News,* 28 May 1870, p.468.

13. See Marc Seguin, *The Cruise of the Breeze*, 2015, pp.198-215.

14. Another version of this fire scene by William Ogle Carlile was published in the *Illustrated London News,* two weeks later. See *Illustrated London News*, 18 June 1870, p. 23.

15. Manuscript copy of a report to His Grace the Duke of Wellington Master General of His Majesty's Ordnance &c. relative to His Majesty's North American provinces / by a commission of which M. General Sir James Carmichael Smyth was President, Lieut. Colonel Sir George Hoste, Captain Harris members, 1825. LAC OCLC-62939771

16. Memorandum from Sir John Burgoyne, Inspector-General of Fortifications, to G.C. Lewis, Secretary of State for War, Feb. 1862 John Gordon, et al, *Report of the Commissioners Appointed to Consider the Defence of Canada.* Province of Canada, 1862. App.2,

17. Gordon, et al, *Report of the Commissioners,* ibid. pp.5-6.

18. ibid., pp 27-29.

19. Jervois commenting on his original February 1864 report in a
letter to William McDougal, Province of Canada Provincial Secre-
tary, Quebec, 10 Nov. 1864, from the 2nd report, "Report on the
Defence of Canada", Quebec, 1864, p.1.
For the complete text of Jervois's first report, see W.F.D. Jervois, *Re-
port on the Defence of Canada and of the British Naval Stations in
the Atlantic*", February, 1864, Library and Archives Canada, OCLC
63083227.

20. ibid.

21. ibid., p.12

22. ibid., p.8

23. Cardwell to Monck, 21 Jan. 1865. *Papers relating to the confer-
ences which have taken place between Her Majesty's government and
a deputation from the Executive Council of Canada, appointed to
confer with Her Majesty's government on the subject of the defence of
the province,* Quebec, 1865.

24. See Yvon Desloges, *The Forts at Point Lévy*, Ottawa, 1991.

25. £176,567 (CDN$32,660,000+ in 2021 dollars).
ibid., p. 57.

CHAPTER 6 The Last Imperial Garrison

1. Letter Macdonald to Carnarvon, April 14, 1870, LAC John A. Macdonald fonds, Political papers, Letterbooks, MG26-A, vol. 517.

2. See Macdonald, *Troublous Times in Canada,* ibid.

3. See Paul McNicholls, *Journey Through the Wilderness: Garnet Wolseley's Canadian Red River Expedition of 1870*, United Kingdom, 2019.

4. Alexander Campbell to Governor-General John Young , 10 September 1870, *Returns to Address of the Senate and House of Commons Relative to the Withdrawal of the Troops from the Dominion,* Ottawa, 1871, pp.26-30.

5. Lindsay to Governor-General, 27 May 1870 and 16 June 1870, in ...*Withdrawal of the Troops from the Dominion,* Ottawa, 1871, pp.37-40.

6. See Thomas Balch, *The Alabama Arbitration,* Philadelphia, 1900.

7. Robertson -Ross, 15 March 1872, "Annual Report on the State of the Militia for 1871", SP No. 8, Ottawa, 1872, p.63.

8. Toronto *Globe,* 6 April 1871, p.4.

9. Speech to the troops, Niagara Camp, June 17, 1871.
From John Boyd, *Sir George Etienne Cartier, Bart., His Life and Times,* Toronto, 1914, p.294.

10. Ibid.

11. Annex to Order-in-Council 1871-1446, RG2, Privy Council Office, Series A-1-a, Vol. 291, Reel C-3298, Library and Archives Canada.

12. These 70 soldiers from the Royal Artillery who volunteered to join the new Canadian permanent force included the commander of "A" Battery, G.A. French, his second-in-command, D.T. Irwin, and the commander of "B" Battery, T.B. Strange, in addition to 67 sergeants, corporals, bombardiers, gunners and artillery specialists. "Report of the State of the Militia of the Dominion of Canada", *Sessional Paper No. 8,* 1872, p. 50.

13. "A" Battery's second-in-command, De La Cherois Thomas Irwin, was seconded from the Royal Artillery's 3rd Brigade as of July, 1872.
The Volunteer Review and Military and Naval Gazette, 9 September 1872, p. 438.

14. *Hart's Annual Army List,* 1871, p.193
See also T.B. Strange, *Gunner Jingo's Jubilee,* London, 1893.

15. Reginald Farmer, who had been promoted to major in 1868, was now promoted to lieutenant-colonel and given command of the Royal Artillery's 13th Brigade (later transferred to the 17th Brigade). The replacement battery commander, Captain Cardew, was in England and did not join No. 5 Battery at Quebec City until August 1871.
See M.E.S. Laws, ibid. See also *Hart's Annual Army List,* ibid.

16. *The Quebec Daily Mercury,* 11 Nov. 1871, p.2

17. ibid.

18. ibid.

19. *Le Canadien,* Quebec, 13 Nov. 1871, p.2. Translation by Marc Seguin.

20. *The Volunteer Review and Military and Naval Gazette,* Ottawa, 27 Nov. 1871, p.755.

21. *Morning Chronicle Commercial and Shipping Gazette,* Quebec, 13 Nov. 1871, p.1.

The author of this poem may have been Charles Matthew Calderon, a captain in the 1st Battalion, 60th Regiment (King's Royal Rifle Corps).

22. B.H. Martindale and W.O. Carlile *Recollections of Canada,* London, 1873, p.54.

23. *The Times,* London, 2 Dec. 1871, p.9, reprinted in *Kinch's Henley Advertiser,* Henley, Oxfordshire, 9 Dec. 1871, p.5.

24. *The Graphic,* London, 9 Dec. 1871, p.18

25. In 1871, the Canadian Militia stores contained 6,225 rifles of six different types requiring four different calibres of ammunition:
 4,630 Peabody muskets and carbines - .50 calibre
 1,352 Snider-Enfield rifles and carbines - .577 calibre
 228 Starr carbines - .54 calibre
 15 Spencer carbines - .52 calibre
"Report on the State of the Militia of the Dominion of Canada for the Year 1871", SP No. 8, Ottawa, 1872,

26. Upper Canada Historical Arms Society, *The Military Arms of Canada,* Toronto, 1963, p.39.

27. SP No. 8, ibid, pp.49-50

28. See Peter G. Silverman, "A History of the Militia and Defence of British Columbia 1871-1914," University of British Columbia, 1956.

29. SP No. 8, ibid, p.66.

30. G.F.G. Stanley, ibid., p.242.

31. *Report of the State of the Militia of the Dominion of Canada for the Year 1871,* SP No. 8, Ottawa, 1872, p.66.

32. *The Volunteer Review and Military and Naval Gazette, 11 Dec. 1871, p.796.*

EPILOGUE

1. This number does not include the headquarters staffs of the Adjutant-General's office and the office of the General Officer Commanding.
Regulations and Orders for the Militia of the Dominion of Canada, Ottawa, 1883, p.126,

2. G.F.G. Stanley, *Canada's Soldiers*, p.302.

3. Department of National Defence, Canada, eMail from Mr. Derek Abma, Public Relations Office, 31 August 2021.
See also http: // www. army-armee. forces.gc.ca/en/home/organization.page and https://www.canada.ca/en/department-national-defence/corporate/reports-publications/departmental-plans/departmental-plan-2021-22/spending-human-re-sources.html#toc1, accessed 22 August 2021..

4. *Canadian Illustrated News*, 5 Oct 1872, p.214.

5. *Pall Mall Gazette*, London, 21 March 1873, p.12.

6. *London Daily News*, 20 March 1873, p.2.

7. Quebec Daily Mercury, 29 May, 1873, p.3.

8. M.E.S. Laws, ibid, p.1873 (note 82).

9. M.E.S. Laws, ibid.

10. One article in the magazine mistakenly refers to Carlile as "Major Carlile" when, in fact, he would only be promoted to captain in November 1874. See *Annual Army List*, 1875, p.171.
Illustrated London News, 29 Nov. 1873, p.500; 20 Dec. 1873, p.597, and 4 Jan. 1874, p.13.

11. See W.H. Askwith, *List of Officers of the Royal Regiment of Artillery*, (4th ed.), pp.78-78a.

12. *Colonial and Indian Exhibition Official Catalogue,* "Pictures Shown in Gallery of Royal Albert Hall", London, 1886, p.xciv.

13. Obituary of Lieut.-Col. William Ogle Carlile, *Army and Navy Gazette*, London, 1 June, 1907, p.520.

14. In 1893, a cost-sharing agreement between Britain and Canada saw a detachment of Royal Marine Artillery stationed at the Royal Navy's base at Esquimalt on Vancouver Island.
See Peter G. Silverman, "A History of the Militia and Defence of British Columbia 1871-1914", M.A. Thesis, University of British Columbia, 1956

Bibliography

ARCHIVE SOURCES

Church of England Burial Records, Fleet, All Saints, 1907.

Library and Archives Canada:
 MG26-A, John A. Macdonald fonds, Political papers, Letterbooks.
 RG2, Privy Council Office, Orders-in-Council.
 RG8, "C" Series, British Military.

National Archives U.K.:
 War Office, "Record Book of Officers' Services", Carlile, WO-76-370.
 War Office, "Record Book of Officers' Services", Martindale, WO-25/3913/155.

BOOKS

——- *The Colonial and Indian Exhibition, London, 1886.* London, 1886.

Askwith, W.H. *List of Officers of the Royal Regiment of Artillery from the year 1716 to the Year 1899,* 4th ed. London, 1900.

Balch, Thomas W. *The Alabama Arbitration.* Philadelphia, 1900.

Barrington de Fonblanque, Edward. *Treatise on the Administration and Organization of the British Army.* London, 1858

Bernier, Serge. *Canadian Military Heritage,* vol. III. Montreal, 2000.

Biddulph, Robert. *Lord Cardwell at the War Office: A History of His Administration 1868-1874.* London, 1904.

Bourne, Kenneth. *Britain and the Balance of Power in North America 1815-1908.* London, 1967.

Boyd, John. *Sir George Etienne Cartier, Bart., His Life and Times.* Toronto, 1914.

Boyko, John. *Blood and Daring: How Canada Fought the American Civil War and Forged a Nation.* Toronto, 2013.

Bruce, Anthony. *The Purchase System in the British Army 1660-1871.* London, 1980.

Butler, Lewis. *The Annals of the King's Royal Rifle Corps*, vol. III. London, 1926.

Callwell, Charles and Headlam, John. *The History of the Royal Artillery from the Indian Mutiny to the Great War,* Woolwich, 1931.

Carlile, William O. and Martindale, Ben H. *Recollections of Canada.* London, 1873.

Chartrand, René. *Canadian Military Heritage,* vol. II. Montreal, 1995.

Cherrier & Son. *The Quebec Directory for 1871-72.* Quebec, 1872.

Chester, Grenville J. *Transatlantic Sketches in the West Indies, South America, Canada and United States.* London, 1869

Clark, Alan and Laurel. *Comics: An Illustrated History.* London, 1991.

Cook, Adrian. *The Alabama Claims: American Politics and Anglo-American Relations, 1865-1872.* London, 1975

Creighton, Donald. *The Road to Confederation: The Emergence of Canada, 1863-1867.* Toronto, 1964.

Dashwood, R.L. *Chiploquorgan or Life by the Camp Fire in Dominion of Canada and Newfoundland.* Dublin, 1871.

Desloges, Yvon. *The Forts at Point Lévy.* Ottawa, 1991.

Doughty, Arthur G. *The Elgin-Grey Papers 1846-1852.* Ottawa, 1937.

Duncan, Francis. *Our Garrisons in the West.* London, 1864.

Ferns, J. Hamilton. *Military Montreal in the Sixties.* Montreal, 1919.

Fortescue, J.W. *History of the British Army,* vol. IV-Part II. London, 1915.

Fortescue, J.W. *History of the British Army,* vol. XIII. London, 1930.

Foreman, Amanda. *A World On Fire: Britain's Crucial Role in the American Civil War.* New York, 2010.

Goodspeed, D.J. (ed.) *The Armed Forces of Canada 1867-1967: A Century of Achievement.* Ottawa, 1967.

Granatstein, J.L. *Canada's Army: Waging War and Keeping the Peace.* Toronto, 2002.

Gray, John H. *Confederation, or the Political and Parliamentary history of Canada.* Toronto, 1872.

Guggisberg, F.G. *"The Shop."* London 1900.

Harper, J. Russell. *Early Painters and Engravers in Canada.* Toronto, 1970.

Hart, H.G. *Annual Army List.* London, various dates between 1840 and 1907.

Harris, Stephen J. *Canadian Brass: The Making of a Professional Army 1860-1939.* Toronto, 1988.

Hitsman, J. Mackay. *Safeguarding Canada 1763-1871.* Toronto, 1968.

Irwin, Patrick. *An Army Officer's Life in Canada.* Montreal, 1992.

Laws, M.E.S. *Battery Records of the Royal Artillery 1859-1877.* Woolwich, 1970.

Leggo, W.A. *La leggo-typie: procédé photo-électrotypique breveté au Canada, aux Etats-Unis, en Angleterre, en France et en Belgique.* Ottawa, 1867,

LeMoine,J.M. *Maple Leaves: Canadian History, Literature, Sport.* Quebec, 1873.

Lovell, J. *Lovell's Canadian Dominion Directory for 1871.* Montreal, 1871.

Lovell, J. *Montreal Directory for 1868-69.* Montreal, 1869.

Lovell, J. *Montreal Directory for 1869-70.* Montreal, 1870.

Lovell, J. *Montreal Directory for 1871-72.* Montreal, 1872.

Lovell, J. *Lovell's Province of Quebec Directory for 1871.* Montreal, 1871.

Macdonald, John. *Troublous Times in Canada: A History of the Fenian Raids of 1866 and 1870.* Toronto, 1910.

Majendie, V.D. *The Arms and Ammunition of the British Service.* London, 1880.

McAlpine, David. *McAlpine's Halifax City Directory for 1873-74.* Halifax, 1874.

McLintock, H.A. (ed.) *An Encyclopaedia of New Zealand.* Wellington, 1966.

McMann, Evelyn de R. *Biographical Index of Artists in Canada.* Toronto, 2003.

McNicholls, Paul. *Journey Through the Wilderness: Garnet Wolseley's Canadian Red River Expedition of 1870.* United Kingdom, 2019

Moritz, Albert. *Canada Illustrated: The Art of Nineteenth-Century Engraving.* Toronto, 1982.

Morton, Desmond. *A Military History of Canada, from Champlain to the Gulf War.* 3rd ed. Toronto, 1992.

Nicholson, G.W.L. *The Gunners of Canada: The History of the Royal Regiment of Canadian Artillery.* Toronto, 1967.

Porter, Whitworth. *History of the Corps of Royal Engineers,* vol. II. London, 1889.

Preston, Richard A. *The Defence of the Undefended border: Planning for War in North America 1867-1939.* Montreal, 1977.

Rioux, Christian. *The Royal Regiment of Artillery in Quebec City 1759-1871.* "History and Archaeology No. 57". Ottawa, 1982.

Royal Artillery Institution. *List of Officers of the Royal Regiment of Artillery.* Woolwich, 1869.

Saunders, Ivan J. *A History of Martello Towers in the Defence of British North America, 1896-1871.* "Occasional Papers in Archaeology and History", No. 15. Ottawa, 1976.

Short, Adam and Doughty, Arthur G. *Canada and Its Provinces,* vol. 6. Toronto, 1914

Seguin, Marc. *The Cruise of the Breeze: The Journal, Art and Life of a Victorian Soldier in Canada.* Prince Edward County, Canada, 2018.

Seidle, F. Leslie and Massicotte, Louis (eds.) *Taking Stock of 150 Years of Responsible Government in Canada.* Ottawa, 1998.

Senior, Elinor Kyte. *Roots of the Canadian Army: Montreal District 1846-1870.* Montreal, 1981.

Stacey, Charles P. *Canada and the British Army 1846-1871,* rev. ed. Toronto, 1963.

Stanley, George F.G. *Canada's Soldiers: The Military History of an Unmilitary People.* Toronto, 1974.

Strange, T. Bland. *Gunner Jingo's Jubilee.* London, 1893.

Upper Canada Historical Arms Society. *The Military Arms of Canada.* Toronto, 1963.

Verner, Willoughby. *The Military Life of H.R.H. George, Duke of Cambridge,* vol. I. London, 1905.

Vieth, Frederick Harris D. *Recollections of the Crimean Campaign and the Expedition to Kinburn in 1855.*

Waite, P.B. *The Life and Times of Confederation 1864-1867.* Toronto, 2001.

Waite, P.B. *The Confederation Debates in the Province of Canada, 1865.* Toronto, 1963.

Wallace, Nesbit W. *A Regimental Chronicle and List of Officers of the 60th or The King's Royal Rifle Corps.* London, 1879.

Whitfield, Carol M. *Tommy Atkins: The British Soldier in Canada, 1759-1870.* "History and Archaeology No. 56. Ottawa, 1981.

Winks, Robin W. *The Civil War Years: Canada and the United States,* 4th ed. Montreal, 1998.

Woods, Joseph. *The Newfoundland Almanac for the Year 1866.* St. John's, 1865.

GOVERNMENT PUBLICATIONS

CANADA

——- *Guide to Fort Lennox, Ile aux Noix, Quebec.* Ottawa, 1920.

Adjutant-General's Office. *Regulations and Orders for the Militia of the Dominion of Canada.* Ottawa, 1883.

Gordon, J.W. et al. *Report of the Commissioners Appointed to Consider the Defence of Canada.* Montreal, 1862.

Canada Parliament. *Annual Report on the State of the Militia for 1870.* Sessional Paper No. 7. Ottawa, 1871.

Canada Parliament. *Canada Gazette,* No. 17, Vol. V. Ottawa, October 21, 1871.

Canada Parliament. *Canada Gazette,* No. 19, Vol. V. Ottawa, November 4, 1871.

Canada Parliament. *First Reading of a Bill Respecting the Militia and Defence of the Dominion of Canada.* Ottawa, 1868.

Canada Parliament. *Fortifications and Defence, Arms, &c.* Ottawa, 1869.

Canada Parliament. "General Statement of Expenditure", *Sessional Paper No. 12*, Session 1867-68, Ottawa, 1868.

Canada Parliament. *Regulations and Orders for the Active Militia of the Dominion of Canada.* Ottawa, 1870.

Canada Parliament. *Report on the State of the Militia of the Dominion of Canada for the year 1872.* Sessional Paper No. 9. Ottawa, 1873.

Canada Parliament. *Return to Addresses of the Senate and House of Commons Relative to the Withdrawal of the Troops from the Dominion, and on the Defence of the Country, and Honorable Mr. Campbell's Report.* Ottawa, 1871. Also appears in *Sessional Paper No. 45*, Session 1871, Ottawa, 1871.

Canada Parliament. "Return to an Address of the House of Commons date 18th March 1868… on the subject of Colonial Military Expenditure and Military Defence of the Late Province of Canada", *Sessional Paper No. 63*, Session 1867-68, Ottawa, 1868.

Jervois, W.F. Drummond. *Report on the Defence of Canada. 10 November 1864.* Quebec, 1864.

Province of Canada Parliament. *An Act to Regulate the Militia of this Province.* Quebec, 1855.

Province of Canada Parliament. *Annual Volunteer and Service Militia List of Canada.* Ottawa, 1866.

Province of Canada Parliament. *Papers relating to the Conference which have taken place between Her Majesty's Government and a Deputation from the Executive Council of Canada, appointed to confer with Her Majesty's Government on the subject of the Defence of the Province.* Ottawa, 1865.

GREAT BRITAIN

Adjutant-General's Office. *The Queen's Regulations and Orders for the Army.* London, 1859.

Hansard U.K.
> Vol. 163 - Mr. Disraeli commenting on Lord Palmerston's remarks, 24 June 1861,
> Vol. 165 - Reinforcements to Canada, 17 February 1862.
> - Resolution, Commons Chamber, 4 March 1862.
> Vol. 191 - Supply – Army Estimates, 23 March 1868 .
> Vol. 194 - Supply – Considered in Committee, Land Forces, 11 March 1869.

Foreign Office. *Papers Relating to the Blockade of the Ports of the Confederate States.* London, 1862.

Jervois, W.F. Drummond. *Letter to the Secretary of State for War with Reference to the Defence of Canada.* London, 1865.

Jervois, W.F. Drummond. *Report on the Defence of Canada and of the British Naval Stations in the Atlantic.* London, February, 1864.

U.K. Parliament. *Canada (Transport of Troops, &c.), Return to an Address of the Honourable The House of Commons, 6 April 1865.* London, 1865.

U.K. Parliament. *Canada (Warlike Stores &c.), Return to an Address of the Honourable The House of Commons, 1 May 1872.* London, 1873.

U.K. Parliament. *Correspondence Relating to the Civil List and Military Expenditure in Canada.* London, 1851

U.K. Parliament. *Correspondence Respecting the Negotiations with the United States' Government on the Questions of the "Alabama" and British Claims, Naturalization, and San Juan Water Boundary.* London, 1869.

U.K. Parliament. *Military Establishments, North America: Return to an Address of the House of Lords, 27th May 1856.* London, 1856

U.K. Parliament. *Report of resolutions adopted at a conference of delegates from the provinces of Canada, Nova Scotia, and New*

Brunswick, and the colonies of Newfoundland and Prince Edward Island : held at the city of Quebec, October 10, 1864, as the basis of a proposed confederation of those provinces and colonies. London, 1865.

U.K. Parliament. *Report on the Affairs of British North America from the Earl of Durham.* London, 1839.

INTERNET SOURCES

Canada, Department of National Defence. http: // www. army-armee. forces.gc.ca/en/home/organization.page and https://www.canada.ca/en/depart-ment-national-defence/corporate/reports-publications/departmental-plans/depart-mental-plan-2021-22/spending-human-resources.html#toc1. Accessed 22 August 2021

Dictionary of Canadian Biography.
 "Desbarats, George-Edouard". http://www.biographi.ca/en/bio/
 desbarats_george_ edouard_12E.html. Accessed 30 June 2021.
 "French, Sir George Arthur".
 http://www.biographi.ca/en/bio/french_george_ arthur_15E.html.
 Accessed 30 June 2021.
 "Leggo, William Augustus." http://www.biographi.ca/en/bio/leggo_william_
 augustus_14E.html. Accessed 30 June 2021.
 "Strange, Thomas Bland". http://www.biographi.ca/en/bio/strange_
 thomas_bland_15E.html. Accessed 30 June 2021.

Officer, Lawrence H. and Williamson,Samuel H. "Five Ways to Compute the Relative Value of a UK Pound Amount, 1270 to Present," *MeasuringWorth, 2020.* https:// www.measuring-worth.com ukcompare/ result.php?year_source=1859 &amount=500& year_result=2019#. Accessed 14 January, 2021

William Leggo Patents. Library and Archives Canada. https://www.bac-lac.gc.ca/eng/discover/patents-1869-1919/Pages/ list.aspx?PatentHolder Search=Leggo&. Accessed 22 July 2021.

NEWSPAPERS

Army and Navy Gazette. London, U.K.

Broad Arrow. London, U.K.

Canadian Illustrated News. Montreal, Canada.

Cork Examiner, Cork, Ireland.

Daily Mercury. Quebec, Canada.

Evening Standard. London, U.K.

Illustrated London News. London, U.K.

Kinch's Henley Advertiser. Henley, Oxfordshire, U.K.

Le Canadien. Quebec, Canada.

L'Opinion Publique Journal Illustrée. Montreal, Canada.

London Daily News. London, U.K.

Morning Advertiser, London, U.K.

Morning Chronicle. Quebec, Canada.

Naval and Military Gazette and Weekly Chronicle of the United Service, London, U.K.

New York Times. New York, U.S.A.

Pall Mall Gazette. London, U.K.

The Graphic. London, U.K.

Times. London, U.K.

Toronto Globe. Toronto, Canada.

Volunteer Review and Military and Naval Gazette. Ottawa, Canada.

PERIODICALS

——- "French View of Our Military Colleges", *Colburn's United Service Magazine*, Part III. London, 1860.

——- "The Pay and Expenses of Officers", *Colburn's United Service Magazine*, Part I. London, 1861

Buchanan-Dunlop, H.D. *Records of the Royal Military Academy Woolwich*. London, 1892.

Burant, Jim. "The Military Artist and the Documentary Art Record", *Archivaria*, No. 26, Ottawa, 1988.

Dubé, Timothy. "Tommy Atkins, We Never Knew Ye: Documenting the British Soldier in Canada, 1759-1871." *Canadian Military History,* vol. 4, no. 1. Waterloo, Canada, 2012.

Grant, William L. "Canada Versus Guadeloupe", *American Historical Review*, vol. XVII, no. 4, July 1912.

Grebstad, David. "Outpost: The Dominion of Canada's Colonial Garrison in Manitoba, 1870 to 1877." *Canadian Military History,* vol. 28, no. 1. Waterloo, Canada, 2019.

Vineberg, Robert. "The British Garrison and Montreal Society, 1830-1850." *Canadian Military History,* vol. 21, no. 1. Waterloo, Canada, 2015.

UNPUBLISHED SOURCES

Silverman, Peter G. "A History of the Militia and Defence of British Columbia 1871-1914". M.A. Thesis, University of British Columbia, 1956.

Zibro, James. "The Life of Paddy Yank: The Common Irish-American Soldier in the Union Army." PhD dissertation, The Catholic University of America, Washington D.C., 2016.

Index

RA - Royal Regiment of Artillery RE - Corps of Royal Engineers

CPSIA information can be obtained
at www.ICGtesting.com
Printed in the USA
BVHW090315130123
656250BV00006B/38